CARVING THE HISTORIC WESTERN FACE

Schiffer Publishing Ltd

77 Lower Valley Road, Atglen, Pennsylvania 19310

Bob Lundy

X-ACTO is a trademark of X-Acto which is a susidiary of Hunt Manufacturing.
Dremel is a trademark of Dremel Manufacturing Company.

Printed in the United States of America.
ISBN: 0-88740-321-2

We are interested in hearing from authors with book ideas on related topics.

Published by Schiffer Publishing, Ltd.
77 Lower Valley Road
Atglen, PA 19310
Please write for a free catalog.
This book may be purchased from the publisher.
Please include $2.95 postage.
Try your bookstore first.

We are interested in hearing from authors
with book ideas on related subjects.

CARVING THE HISTORIC WESTERN FACE

Table of Contents

About the Author . 6

Preface . 9

Chapter 1 — The Cowboy . 11

Chapter 2 — The Indian . 47

Chapter 3 — Mountain Man . 77

Chapter 4 — Bits and Pieces . 95

 Wood . 96

 Tools . 97

 Repairing Cracks . 99

 Feathers . 102

 Pipes . 105

Friends I Wood Like You to Meet . 107

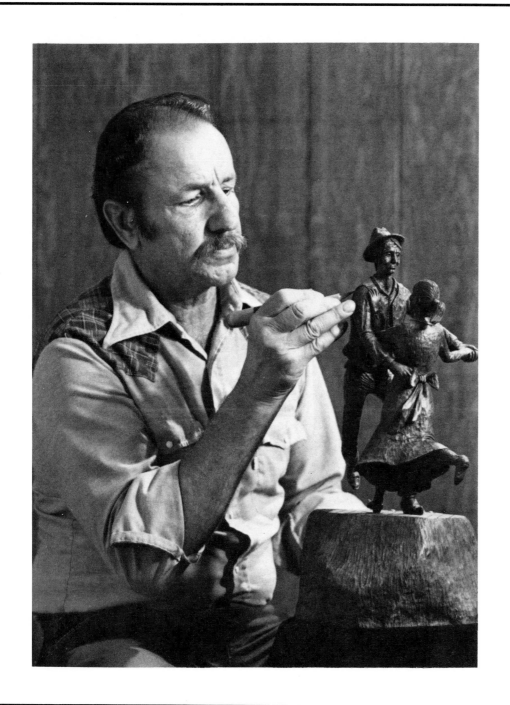

BOB LUNDY

SCULPTOR

ABOUT THE AUTHOR

I was brought up on an irrigated farm in Southern Idaho where I spent a very happy childhood in hard work and play — in that order. Where there is plowing it must be followed by planting. Then the cultivating, the weeding, the watering, the harvesting and in between it all, the *very* regular milking of the cows. To this day, I have retained a burning hatred of milk cows and all other livestock to a lesser degree.

When the work was there we were there, but when the work was done for the day we were free to go and come as we pleased.

It was to the bank of the Snake river, which severed a corner from our farm, that I usually escaped. What wonderful, joyous hours were spent in my own secret, mysterious places but, more often, with my close friends, exploring, hunting, fishing, swimming and anything else a kid does who has a love for the out-of-doors, the wild, the free.

I could well have been a mountain man had I been born in another time. But since I wasn't, the mountain country must be my home. This, in a small way, satisfies my longing. Further satisfaction comes by creating from wood the Western people of that era of which I would love to have been a part.

I wish to thank my wife, Joan, for her unselfish and dedicated support of this book. Without her it would not have been. Our thanks to a very dear member of our family for financial support that was given voluntarily.

We are also indebted to Art and Judie of Rockland Publishing, Inc. for the advice, patience, moral support and expertise so unselfishly offered.

Bill Mackin supplied the know-how for the super black and white picture developing. We thank Bill for that. Also thanks to the folks at Clayborn Graphics for the extraordinary work in creating the cover.

My gratitude to the God of Heaven who abundantly supplied the strength and wisdom in **this** effort as well as in the every day walk of all who seek him.

Bob Lundy
October, 1987

PREFACE

I am not of the old school of wood carvers. I certainly have no quarrel with those who are, for I have seen their work. No sculpture can be made better than with the meticulous use of well kept and well sharpened hand tools. Faster, perhaps, but no better.

I, too, use hand tools but only after the excess wood has been removed by the much faster power tools. After all, it is only when the unwanted wood is removed that a work of art can be brought to light. Regardless of how homely it may be in the process, the finished work is all that matters.

If you can achieve the same results with hand tools by all means use them. Everyone should use whatever they are comfortable with.

The basic principles set forth in this book apply to any tool as long as it removes the wood where it needs to be removed.

The sharpening of carving tools is an art in itself and those who are devoted to their use have my deepest admiration. Chisels and gouges certainly must be given the loving touch of the hone but for knives I am hopelessly addicted to the throw-away blade.

The successful wood carver must be a self-starter, endowed with an enormous amount of patience and a determination to study. Study what? In this case — **people!** That's what this book is about. If a friend of yours were in a group of people you could identify them at a glance. **Why so easily**? People all look basically the same: two eyes, a nose, a mouth — all in about the same place. Yet each is a little different!

We, as *people* carvers, must accept this challenge. Each carved work must be a person, an individual, with different moods and thoughts and dreams. The carver must create these characteristics in each face. The contrast between individual faces may be extreme, such as a kindly old doctor compared to a tough, trail hardened cowboy. Or it may be subtle, using a slightly opened mouth or an extra wrinkle here and there to bring out the difference.

I have seen carvers get in the rut of sameness. Their Indians may have different hair, the ornaments may vary but the faces are the same. Their cowboys may wear different hats but are identical twins.

If you can learn to make one face you can learn to make another. This is creativity.

Artists must study their subjects, and there are millions of them everywhere. Study the guy you shave each morning, the gal you kiss when you go to work, the boss, the man on the street. There is no end to the lessons to be learned.

A book such as this must be written for both the beginner who is looking for complete *how-to* information from start to finish and for the veteran who is interested only in a tip here and there to improve their work. I, too, need to keep learning and you may know of better and easier methods of doing a particular job suggested here. If so your input would be appreciated. I would really enjoy seeing a picture of your first work as a result of using this book, and having your comments on how it went.

If I can instill within you a feeling of closeness, of intimacy to those you create I will have succeeded. We must view our artistic creations not just as wood carvings or a way to make a buck, but as people, members of the family.

So, letting the chips fall where they may, get to having fun. Good Luck!

CHAPTER 1
THE COWBOY

CHAPTER 1
THE COWBOY

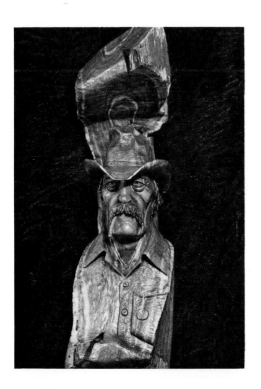

The cowboy was an integral part of the old west. Much of life in those times revolved around him. Not only did he act as a cow nurse: herding, driving, and branding; but he also stacked hay, and built corrals and barns. He should be remembered too for his dedicated defense of the brand he rode for, even in the face of death. The Saturday night shindigs wouldn't have been the same without him either. Most cowboys couldn't dance a lick, but as long as that little gal was in his arms, who cared what the feet were doing! These cowboys were tough men. They were independent but when needed they were there. **A rare breed!**

To carve these qualities into a face is indeed a challenge!

Select a piece of wood with good depth because of the hat brim. Remember, the brim protrudes to the front more than any other part, so it must be the point of reference for the entire piece. The hat is the extremity on the sides as well, and must be given first consideration there.

Decide which side of the piece is best suited for the face — free of knots, cracks, etc — and flatten the opposite side. A chain saw is best for this, or a bandsaw. A handsaw will do the job, too, but finding someone else to run the thing is the tough part.

Now, fasten the piece to **something** at **eye level!** If you lean over your work, you may become one of the chief supporters of the chiropractic profession.

If you intend to become serious about wood carving, purchase a swivel vise. Both hands are free and the work can be turned to any position. Here is the way mine is set up. It is nothing more than a pipe clamp bolted to the swivel vise. Lag screws fasten a foot long piece of 1 ½ inch angle iron to the back of the piece which is then clamped in the vise. Works very well. (Figures 1, 2, and 3)

Determine where the top of the hat will be and remove a wedge (Figure 4). Don't worry about the face yet. It must be carved to **fit the hat. Never** vice versa. This is important. Clean the face area with whatever comes to hand — drawknife, heavy rasp, chainsaw, etc.

The shape of a cowboy's hat was determined solely by the whims and personality of the man who wore it. Your imagination can come into play here. You may have a hat you can look at or you could borrow your buddy's. However, if he is as attached to **his** hat as the real range riders were, he may insist on a royalty from the sale of your first work! You can also find hats in a catalog, but they bear little resemblance to the cowpoke's *lid* — at least after

Figure 1

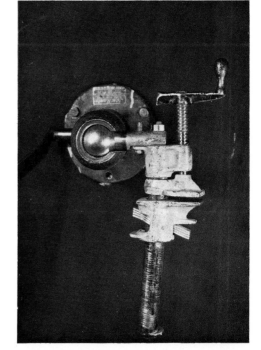

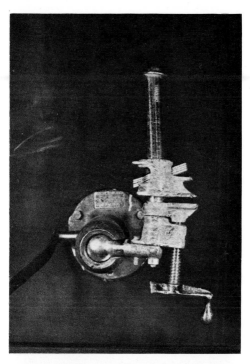

Figure 2

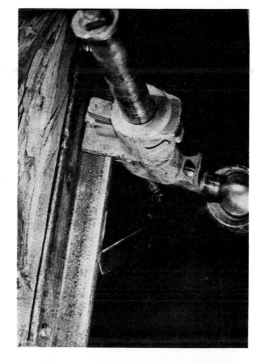

Figure 3

Figure 4

Figure 5

the first day he wore it. Their hats were usually somewhat distorted, so don't be too concerned with symmetry.

A good rule for determining the height of the hat is to divide the width by 1.5. This measurement will be the distance from the top of the crown to the front of the brim. This rule is, of course, very adjustable. The width of the brim will be the width of the piece of wood you have selected, with probably ½ inch trimmed from each side, to eliminate the unstable wood caused by weathering. Measure the width of the piece where the brim will be, subtract an inch, divide by 1.5 and you have the distance from the top down to the brim in front (Figure 5).

You will come to see with your mind's eye the person contained in the wood. You will feel excitement because it is **you,** with your own hands, who will release this individual! The feeling may not come with this piece or even after several more, but it **will** come or my name isn't *Split-Finger Bob.* I know this is fantasy, but nevertheless, the feeling will be within you and you will transfer it to your new *acquaintance.* You will probably talk to this creation and laugh with it as each new feature is developed. You will know where he came from, his dreams and his disposition. Sound silly? It isn't! After all, you are the one creating this person; shouldn't you know him intimately?

Always remember in the roughing out process, to leave plenty of wood for everything. That is one of the secrets of good wood sculpturing: trimming little by little until you get the desired results. But you must have enough wood there to trim, so always be sure you leave plenty.

At this point we have the front of the brim marked (Figure 5). Now, in order to have the brim turned down sharply in the front, mark a line backward and upward on each side as in Figure 6. Continue this line backward on each side (Figure 6). This will be the top edge of the brim.

It looks too high, doesn't it? **It is,** but as was stated earlier, you must leave plenty of wood everywhere. You can always cut it off later.

Now, draw a line on each side where the hat hits the head. Make it slightly oval (Figure 7).

How wide should the head be in relation to the hat? You may have noticed, as I have, a problem beginners have of making the head too large for the hat, and nobody likes a big-headed cowboy. I would rather see the hat too large than too small.

Here is a good rule to follow for determining the ratio of hat brim width to face size. This calculation will vary somewhat depending on whether the hat is flat brimmed, has a sharply turned up brim or is somewhere in between. Divide the width of the brim by 2 to find the width of the face (**just** the face). For example: a six inch brim divided by 2 gives us a face width of 3 inches. Since our cowboy wears the *in-between* type of hat brim, this rule works well. Using this ratio, determine the width of the face on your piece, add ½ inch on each side for his hair, center the face with respect to the hat and mark (Figure 8). When applying this ratio, don't forget any unstable wood which must be trimmed from the sides of the brim.

It seems like a lot of hair we are giving this guy, doesn't it? Well, there was probably a pair of hand operated hair clippers in the bunkhouse, but if they were as dull as the ones used on **my** pointed little head, it can be well understood why the hair on

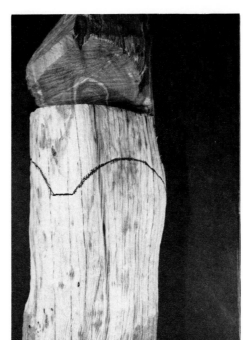

Figure 6

Figure 7

Figure 8

Figure 9

most of the cowpokes in those days was a bit shaggy.

Naturally, the sides of the hat will be on the same line as the sides of the head. Starting there, mark a line straight up on each side (Figure 9). The hat, as you can see, is much too wide at this point, but will be drawn in and shaped as the face is trimmed. You can determine approximately where the top of the head will be inside the hat. Draw a line there (Figure 10). Multiply the width of the **face** by 1.6 and measure **that** distance down from the top of the head: this is the chin line for the average Caucasian face (Figure 11). All of these figures and equations are very adjustable. Don't be afraid to add to, or take from any of them to make the face look right to you. Fill in the line on both sides of the face, sloping inward to the chin (Figure 12) and we are ready to dig this *waddie* out. He's been waiting a mighty long time for this moment so you better keep an eye on him. No telling what he might do once he is free.

Whatever else he might do, there is one thing for sure, he will give an honest day's work for a day's pay. He'll kick those old mossy horns out of the draws, brand and ride with the best, and get away with his share of hard tack and gravy. Complain? Not on your life. Who would gripe about sitting a good horse with the wind in his face and Ma nature for company from sunup to sundown?

I am sure that by now you are ready to start moving wood, so let's get on with it. I like a ³⁄₈ inch straight shank bit in the router for roughing out. Use carbide bits if you can afford them. It pays. Always use the longest bits available. They are better for the hard-to-reach areas.

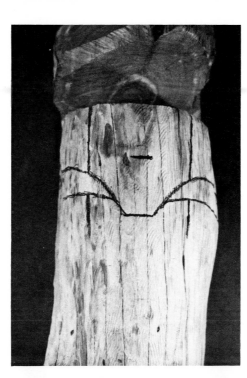

Figure 10

Figure 11

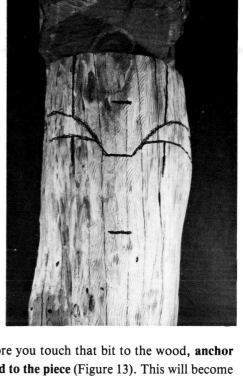

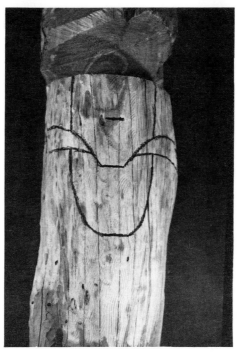

Figure 12

Before you touch that bit to the wood, **anchor your hand to the piece** (Figure 13). This will become second nature to you in no time because if you do not **anchor your hand,** you will have **no** control. Don't be hoggish with that machine. Make light cuts and take a little longer, because the deeper and faster you try to cut, the greater the chance that the machine will grab and kick resulting, perhaps, in a ruined piece!

Starting with the crown of the hat, remove the wood straight back on the lines drawn (Figure 14) and on the brim line on each side. Don't be concerned with the shape of the hat yet, that can be done later.

Now, let's work on the front of the hat. Remember the brim is turned down in front, therefore it must slope upward to where it meets the head. Before you make that cut though, you should

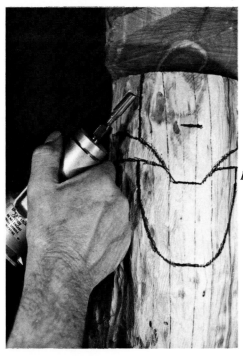

Figure 13

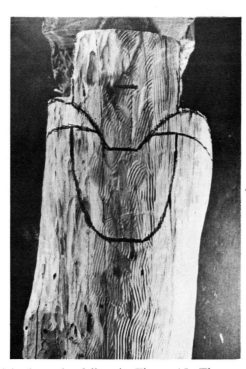

Figure 14

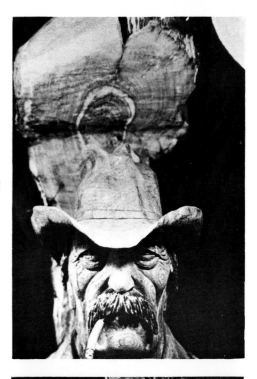

Figure 15

take a good look at the fellow in Figure 15. The brim in front looks as wide as the sides, doesn't it? But you can see in Figure 16 that this is not so. In reality the sides measured on the curl of the brim are 2 inches wide, whereas the front is only 1 ½ inches. It just **looks** the same because of the frontal view. There is no set rule for this except to trust what your eyes tell you. The turned down brim creates a wider appearance, whereas a flat brim can be the same width all around. To put it simply, it just has to look right to you, and that will come with practice.

Slant the brim upward to the crown, far enough to establish the line where they meet, then slope the crown backward. Now it should look like Figure 17.

You need to establish the shoulder line in your mind before you proceed any further. The shoulder

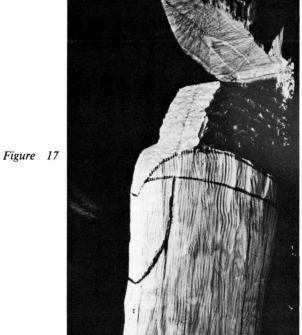

Figure 16

Figure 17

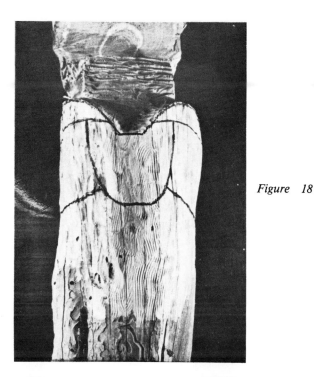

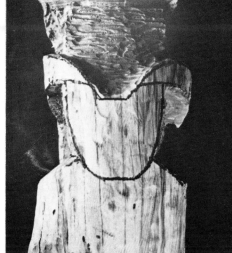

Figure 18

Figure 19

Figure 20

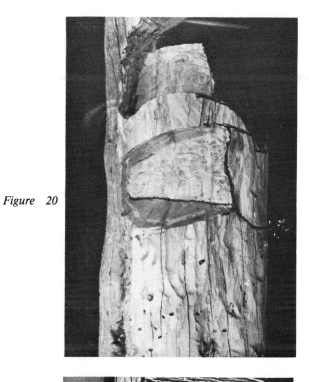

meets the neck on about the same level as the chin. Raise it enough to accommodate the collar, then mark it (Figure 18). You might check in the mirror to make sure it looks right. Remove the wood straight back on both sides of the face, following the hat brim line and the shoulder line (Figures 19 and 20). Be sure to make the cut on the shoulder line horizontal. Notice the line in Figure 20.

Figure 21

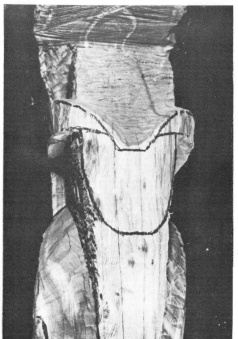

Leaving the wood under the chin for the moment, slope the piece outward and downward from the shoulder to the chest on both sides of the chest. Be sure to leave the shoulder line. Notice the dark line indicating the shoulder line in Figure 22. Don't get carried away here for we have a shirt collar to make, too (Figures 21 and 22). Now, take the wood from under the chin on the same line, and we have ourselves a genuine blockhead (Figure 23)!

There is a great excess of wood in the chest area

Figure 22

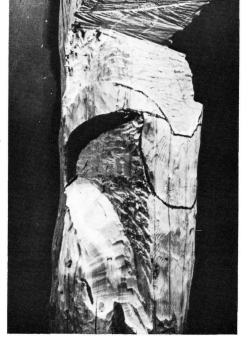

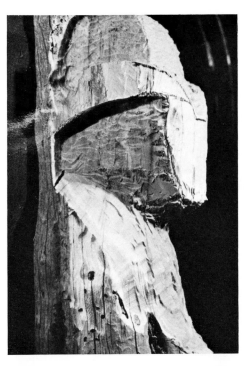

Figure 23

for the same reason that the hat brim is too tall: the first rule of wood carving states that you can take it off, but you cannot put it back on!

If you think you are getting anxious to give this guy a face, how do you think **he** feels? But just tell him to be patient, because if he wants any character and good looks at all we have to be given time! Character takes time to develop. Good looks? I wouldn't know about that.

Let's start right at the front with the face and take it all back together. He may like a big, pointed nose or a short, hooked nose. He may want a prominent chin or a receding chin. But **we** are holding the knife so we will make him as we want. If he doesn't like it, that's too bad! We can always use more firewood!

Draw a couple of dots for eyes just below the

hat brim (Figure 24). We don't care about width yet. The length of the nose is the next consideration. Having sported a *Jimmy Durante* all my life, I guess I felt that to be **outstanding**, a wood sculpture needed a like protuberance! Therefore, that is what most of my first people received. But why should such a burden be thrust upon the unwary? It's not right. So, I have learned to be more gracious and install noses that have a wider range of acceptance in society.

There is no set rule for nose length, but mark this one well above the halfway point between the eyes and chin, and continue the line up and over the eyes (Figure 25). Observe a few noses to see their relative position with respect to the eyes and chin. The nose, as you will see, is not in the middle but considerably higher.

The mustache is next. **Everyone** wore hair on

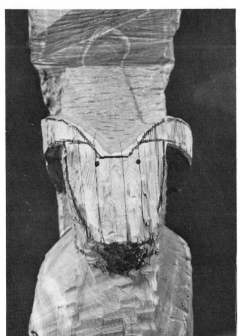

Figure 24

Figure 25

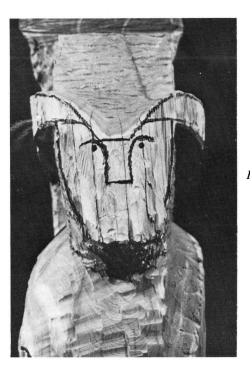

Figure 26

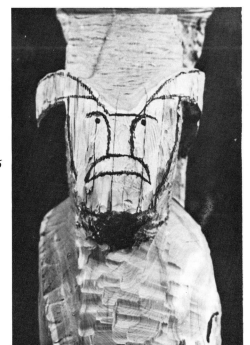

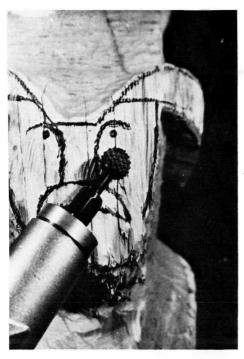

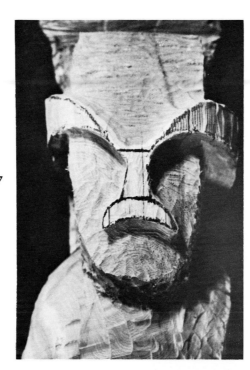

Figure 27

Figure 28

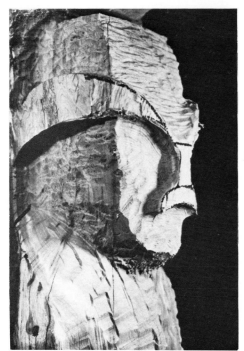

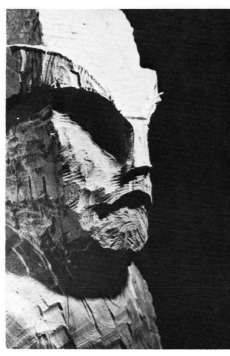

Figure 29

Figure 30

his lip in those days. Well, maybe not everyone, but I've heard it said that if you hired on for a trail drive without one, you would stampede the herd! Those longhorns noticed such things! Let's give him a rather shaggy one. He can get it trimmed next time he's in town. How does this one look (Figure 26)?

Let's get that heavy bit out of the router now. We are getting down to detail and it is a little unruly. For this part of the work I use the $\frac{5}{8}$ inch rotary rasp (Figure 27). It moves the wood well, yet is smooth and controllable.

Beginning on the side of the nose and following the brim line, remove a substantial amount of wood and slope the face toward the back. Follow the nose line downward around the end of the mustache, sloping the entire face to the back. Beneath the mustache and on the other side of the face, do the same (Figures 28 and 29).

Now **nobody's** nose protrudes as far as a hat brim. We need to do something about that. Do **not** use the side view to determine how far back to take the face. If the face looks right in respect to the front of the brim from a side view, it will look far too deep from the **front** (refer back to Figures 15 and 16).

So keeping the old boy facing you, start trimming his face by first removing a lot of hair, or rather, wood, from his mustache, sloping it back on both sides as in Figure 30.

Now, trim the nose and forehead — as far under the hat brim as that big bit will go (Figure 31). Now the eye area should be taken back, shouldn't it? And the chin. Then the mustache and the nose! We are trimming the face as one unit,

maintaining the proper perspective of one part to another, until it looks right in respect to the hat brim.

Of course, the shaping and refining will be done with the knife, so let's stop here, leaving plenty of wood for detail (Figures 32 and 33). It looks good from the front, doesn't it, but the side view is a little distorted. That's the way we want it!

He knows he is soon to be paroled from that wooden prison. If you look closely you can see a twinkle in his eye already!

By the way, are you wearing a dust mask? If not, you will kick yourself after a few years of breathing that dust!

Draw the collar something like this (Figure 34). Change to the ³⁄₈ inch straight shank bit, or if it is a little too hard to control, use a ¹⁄₄ inch bit instead.

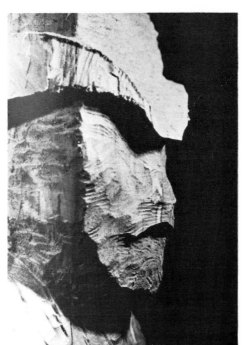

Figure 31

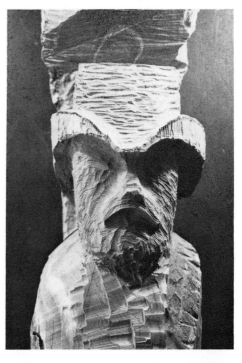

Figure 32

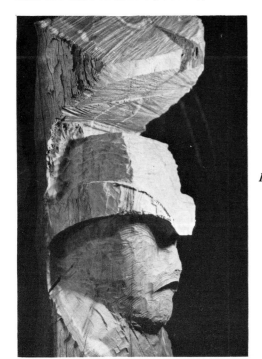

Figure 33

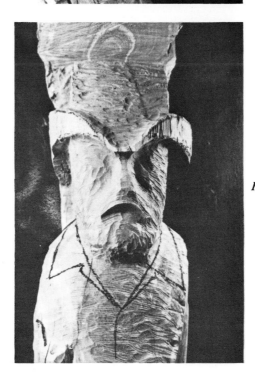

Figure 34

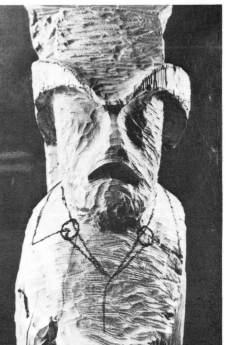

Figure 35

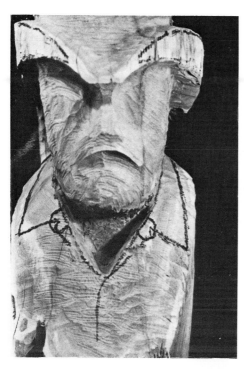

Figure 36

Figure 37

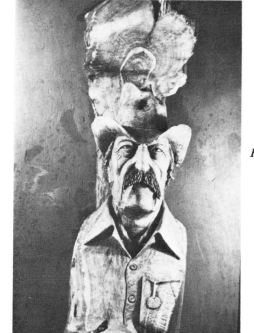

Figure 38

Figure 39

This collar is a stand up type, so the circled spots (Figure 35) will be the focal points of the shirt and must be left at the present level for now.

Start beneath the chin and remove the wood between the collar lines (Figure 36). This creates quite a hole, but we will have to remove some later because everything must be taken back much more in order to be in the correct perspective to the hat.

Leaving the entire collar alone, remove the wood from the whole shirt front and up to the shoulder on each side (Figure 37).

You can finish the piece of wood at the bottom any number of ways. If your piece is shorter than the one I am using here, the shirt can be continued right to the end. With a longer piece, such as this one, simply blend it with the uncarved wood. It would look something like Figure 38.

Change back to the ⅝ inch rotary rasp and smooth the entire shirt front. Now slope the sides of the collar downward as in Figure 39, leaving the focal points (circled) as they are. Now, beginning at the circled spots, slope the front of the collar downward to blend with the shirt front (Figure 40). Remember we are still in the *roughing out* process, and a lot of trimming and adjusting must be completed. Don't even **try** to make any part look finished until it **is** finished. Don't remove any wood from **under** the front of the collar yet. That can be done only **after** we are sure of its exact position.

I like to use a ³⁄₁₆ inch round bit for the next job but it has a ⅛ inch shank, so a collet must be used to reduce the machine from a ¼ inch drive to ⅛ inch. (Refer to Appendix I, Tools)

We must get his face back to where it is correct in respect to the hat brim, for only then can we

Figure 40

Figure 41

determine where his hair and ears should be positioned. Give him a forehead by removing the wood from beneath the hat brim in front. Now, take the entire face back, maintaining the same general shape. Keep the mustache trimmed straight in on the bottom.

Maybe we should stop about here (Figures 41 and 42). This leaves us plenty of wood for the knife.

This feller was telling me the other day that there was one good thing about having no ears — he couldn't hear the boss chew him out. He figured he would like to have a set though, so he could hear the coyotes sing. He said he wasn't too wild about having to listen to his pardner Curly yodel, but guessed he would have to, just to get that coyote music. It won't be long till sundown when the coyotes get busy, so let's get going on this ear job.

Turn the piece sideways to a vertical position (Figure 42). We want to establish where his ear and hair lines will be. On most people the bottom of the earlobe is slightly lower than the nose. Make a mark (Figure 43).

A pair of calipers would come in handy for the next measurement. If you don't have calipers you can eye-ball it with a ruler. The distance, from the tip of the nose to the **front** of the earlobe is approximately the same as the width of the face at the cheekbones. Don't forget, some of that wood on the side of his head is for hair, so adjust your measurement accordingly. Measure and mark (Figure 44). If the depth of the piece does not allow the ears in that position, they can be moved to the front considerably with no noticeable difference. The top of the ear is usually slightly higher than the eye. Mark and draw the ear as in Figure 45.

Figure 42

Figure 43

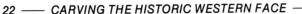

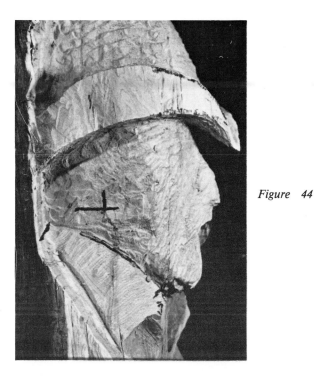

Figure 44

Figure 45

Figure 46

Figure 47

Remember, the hair on these old cowpokes was more often than not a little ragged. This feller's was no exception; it hung over his ears (Figure 46). Give him a little different look on the other side. Leave more or less of the ear showing, or all of it if you like.

It's exciting, isn't it, when you can see your masterpiece slowly but surely emerging from the wood? Each cut you make brings it a little closer to reality; so unlike the molding of clay or wax where there evolves a certain looseness, because any error can be corrected or changes brought about with just another dab here or there. A closer affinity develops with the **people** in the wood, for we seem to hear them say at times, *Whoa, don't cut there, that wouldn't be me!* Each one becomes a part of its maker because of the tender touch, the patience and the love we must employ to make them one with us.

Draw in the jaw line about like this (Figure 47). It will have to be raised later because his chin is much too low. Using the ¼ inch straight shank bit, remove the wood between the jaw and collar lines, below and behind the ear, back to the hair line (Figure 48). The neck turns in rather sharply there as you can see by the depth of the cut. Now, turn the face to the front and mark about ⅜ inch in at the cheekbones on each side, which leaves an eighth of an inch or so for shaping (Figure 49). Remove the wood on that line straight back to the hair and ear lines (Figure 50).

Now, using the ³⁄₁₆ inch round bit again, slope the ears from front to back following the hair line (Figure 51). Since the hair must come from under the hat and out over the ears, we need to slope it inward from the top of the ear. Now, slope the hair inward at the back to *disappear* behind the head.

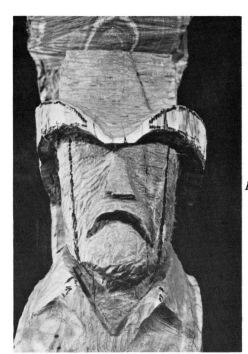

Figure 48

Figure 49

Figure 50

Figure 51

Figure 52

Run the tool behind the hair at the back so it **does** disappear. Also, the collar must turn in behind the neck. Leave the hair on the outside of the collar (Figure 52). If your piece has enough depth, turn the shoulder downward at the back, so it also disappears.

While you are at it, trim the top of the collar in closer to the neck. This will do for now (Figure 53).

The reason the chin is longer now than at the start, is because we carved the neck inward on a downward slant, and as we cut the chin back it followed the downward slant and thus became longer. Raise the chin now, and remove more wood from the neck between the collar lines (Figure 54). Of course, this leaves a lot of room between his chest and shirt, but all we wanted at the moment was to get his chin and neck a little closer to the correct shape, so let's leave the shirt front as is for

Figure 53

Figure 55

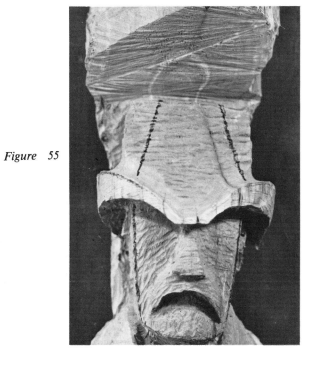

Figure 54

Figure 56

Figure 57

now. Besides, he needs a pocket with a Bull Durham sack in it, so we must leave wood for that.

We need to do some work on that hat so we have something to fit the head to. Using the $\frac{5}{8}$ inch rotary rasp, smooth both sides of the brim alike and curve them inward at the back.

Let's lower the brim now about on the line in Figure 55. Trim the sides of the crown on the lines shown in Figure 56 so the hat and head will come together in the proper place (Figure 57). Both will need more adjusting later, but we're making a man out of this hunk of wood, don't you agree?

Don't be afraid to sit back and study the work done thus far. I find myself doing this quite often, not because I am fearful of the next stage or doubtful of how to proceed, but simply to acquaint myself with this individual. I need to know the mood he is in, what's on his mind, on which side of

Figure 58

Figure 59

his mouth he holds his smoke, or the tilt of his hat. Get acquainted! His emergence will be much smoother.

Now, round the corners of the crown with the ⅝ inch rotary rasp (Figure 58). It is actually beginning to **look** like a hat, don't you think? You have no doubt noticed several cracks in the hat brim and other places on my piece. We will take care of them when the piece is nearly done. If cracks are filled too soon, the subsequent wood removal may go beyond the repair and will have to be re-done.

Using the same tool, let's remove the wood from between the crown and brim, leaving the edge of the brim at least ¼ inch wide (Figure 59). This ensures us plenty of wood for shaping. Round the bottom sides of the brim inward and downward, curling it under more sharply as you approach the front (Figure 60).

We have one more little job before we pick up the knife. Still using the ⅝ inch rotary rasp, slope the face to the back, narrowing the face from beneath the cheekbones downward, including the chin (Figures 61 and 62). Go back and up beneath the cheekbones all the way to the ears.

Now, we are ready for the knife! Use whatever kind of knife that feels comfortable to you. I like the working part — the blade — very close to my finger tips for control and feel, so I have chosen the Xacto® knife. There is more than one style and I like the heavy-handled one. It gives you something to get hold of and will not turn in your hand. The number 24 blade is my favorite with the number 11 coming in second. It gets most of the work around the eyes. Just remember to keep both hands on it, and you will not be supporting Johnson & Johnson nearly as much! Turn the piece horizontally. This

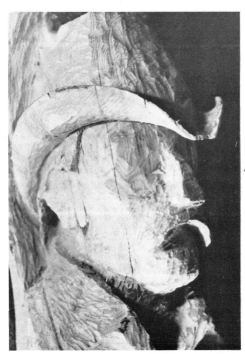

Figure 60

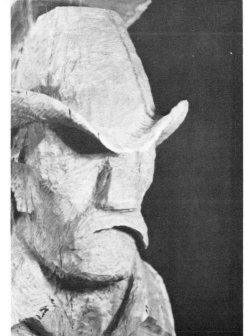

Figure 61

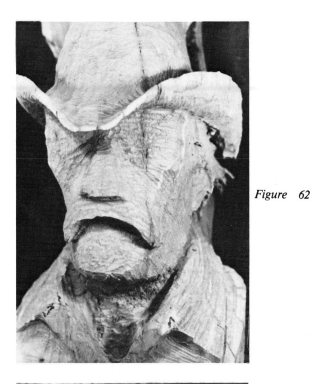

Figure 62

will enable you to make a deep cut inward and upward beneath the brim and around to the hair. Trim the forehead and the sides up to the cut. You will no doubt have to turn the piece several times to get the desired results. It will need more adjusting, but it should now look like Figure 63.

Since the nose is the reference point, that is where we start. Cut each nostril straight back on a bevel (Figure 64), then trim the sides on a bevel and cut off that sharp point, bevelling inward like this (Figure 65). Since most of these galoots would fight at the drop of a hat, their noses took on many peculiar shapes. Our man took a good *roundhouse right* only last Saturday night, but it tended only to make the *hook* a little more pronounced; about like this (Figure 66).

Very few of the western cowmen carried watches in those days so they told time by the sun.

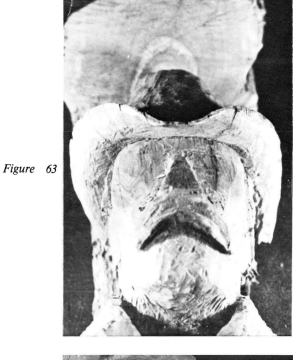

Figure 63

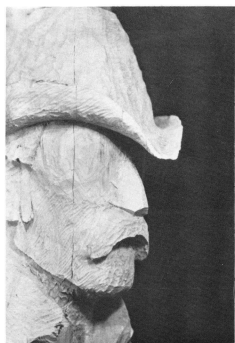

Figure 64

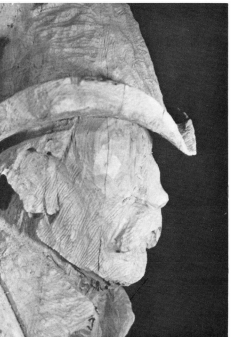

Figure 65

Figure 66

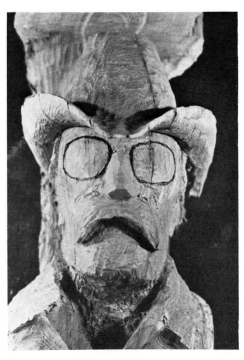

Figure 67

Figure 68

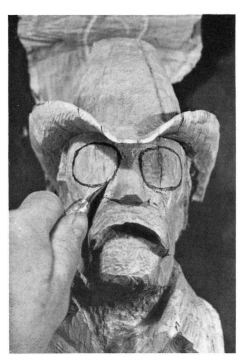

He needs a pair of eyes though or he won't know when it's quittin' time. Draw an oval on each side as shown in Figure 67. Then, cut inward on a bevel all around each oval as you see in Figures 68 and 69. Trim the ovals outward and backward to the cut, leaving the rounded *bumps* where the eyes will be (Figures 70 and 71). Using a ruler make sure the tops of the bumps are even. Now, hold the piece in a horizontal position, face up, and eyeball it from the bottom end and check the bumps. Are they at the same level? Measure each oval from the center of the nose for uniformity. Make sure each has the same roundness. Study someone's eye and notice how much the outer end slopes to the back. Be sure the ovals are cut far enough toward the back of the head at the outer edge to accommodate the backward slope of the eye. Notice Figure 71.

We can give this feller any kind of eyes he

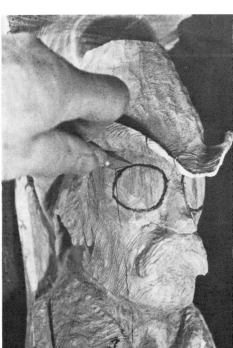

Figure 69

Figure 70

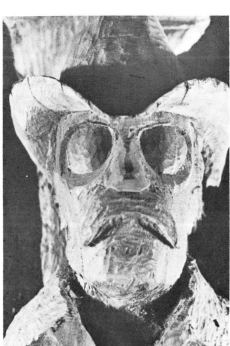

Figure 71

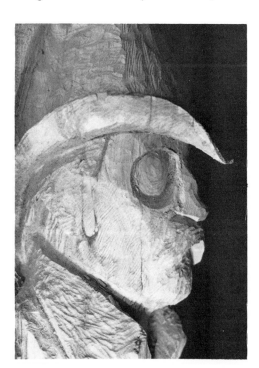

wants — evil, gentle, wild, etc. Since our Indian's eyes are a little on the wild side, let's give this old cowpoke a gentle look. A word of caution though — don't ruffle his feathers. He can become *un-gentle* in a hurry! How about this model (Figure 72)?

I would suggest putting a sharp blade in your knife; the eyes require a delicate touch. Before a cut is made, be sure both eyes are the same distance from the center of the nose and are the same width. The tops should be even as well as the inner and outer corners. Make a light cut straight in completely around the eye. Repeat several times, going a little deeper each time. Because the number 11 Xacto blade is such a long, fine blade, it is ideal for shaping the eyeballs. Carve them in farther than is normal. This adds impact (Figure 73).

We need to have more curvature to the eye area — both top and bottom. The focal point is the center of the upper eyelid. It must be left at its present level. Make a deep cut straight in as shown in Figure 74. Then, beginning where the knife is (Figure 75), follow the oval all the way around the bottom (Figure 76) to connect with the cut in Figure 74.

Now, my fellow eye surgeon, we are about to give this man the greatest physical gift of all — sight. We value the sense of sight above all others, don't we? To hear the sudden clap of thunder is awe inspiring, but to **see** the thunder's sire cleaving the blackened sky brings a renewed awareness of the frightening power of the Creator. To hear the waterfall in no way compares to the vision of the mighty cataract plunging to the depths below — or a rose — a snow capped peak — a beautiful woman?

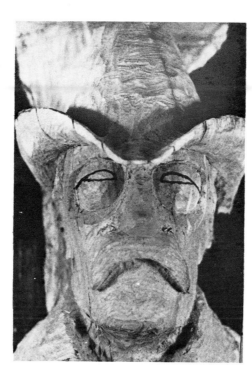

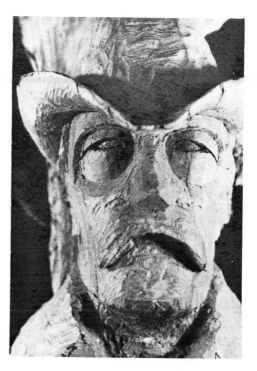

Figure 72

Figure 73

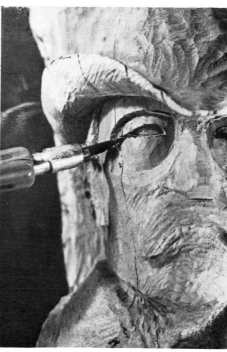

Figure 74

Figure 75

Figure 76

Figure 77

Figure 78

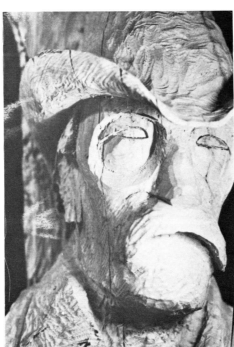

Figure 79

Figure 80

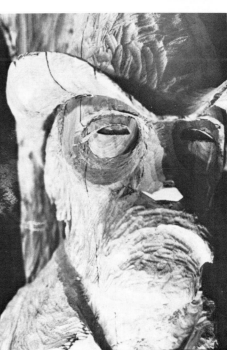

Figure 81

Uh, perhaps we should get back to carving!

We need to exercise a lot of care here, for the eyes make the face — living or otherwise! First, make **this** cut (Figures 77 and 78). Remember, we are just giving the eye area a more pronounced oval from side to side. Then, **this** cut (Figures 79 and 80). Now, trim the lower lid down to the cut on the bottom, maintaining the oval. Give the lid an inward slant toward the bottom (Figures 81 and 82). Cut the rest of the way around the top lid (Figure 83). Trim the lid upward and backward to the cut, maintaining the oval and leaving undisturbed the very front and center. Figures 84 and 85 show this cut.

The next step is difficult to put into writing, but we must make the indentation that runs from the outer edge of the eye, above the cheekbone and back to the ear. In the same process, the eyelid must

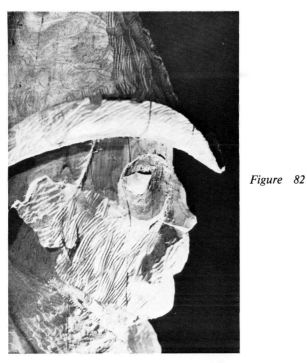

Figure 82

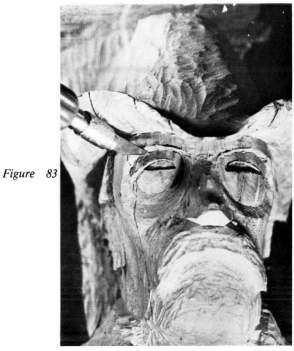

Figure 83

Figure 84

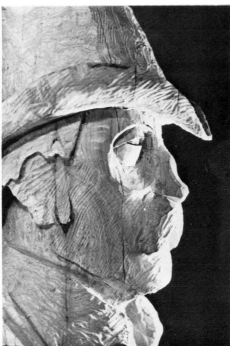

Figure 85

be blended with the brow at the outer end, yet leaving a groove where the eye meets the bone of the socket. Also, slope the temples inward and upward toward the top of the head. I will use the $3/16$ inch round bit — it is better than the knife for this job. This is what it should look like (Figures 86 and 87). I had to bring the cheekbone in a little. You probably should, too.

Let's finish the other eye now and get that out of the way. Make sure the outer ends of the eyes are equidistant from the center of the nose. We want all the extremities — top, bottom, inner, and outer ends to be even horizontally. The bottom of the ovals must also be even. Check to be sure the cheekbones are an equal distance from the nose.

As you can see, there is too much wood directly beneath the eyes and on the sides of the nose. Using the same tool (the $3/16$ inch round bit) trim this area

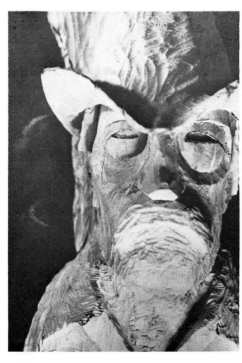

Figure 86

Figure 87

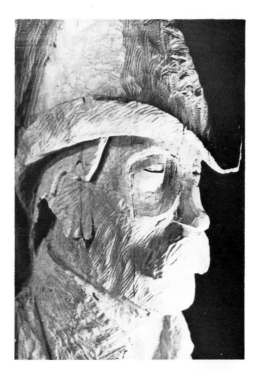

down. He needs to have a weather-beaten, rawboned look, so continue the cut downward beneath the cheekbones. He is beginning to take on a rugged appearance now, don't you think? See Figures 88 and 89.

You can see as well as I that the nose is too wide between the eyes. Narrow it and make a groove across the nose where it meets the forehead. Smooth the brows a little, being careful not to touch the eyelids with that tool! Figures 90 and 91.

OK, so his nose is too long! That's the way it is with wood sculpture — when you remove wood in one area it causes another feature to be out of proportion. Yogi Berra once said, 'It ain't over till it's over.' The same is true with carving. It ain't done till it's done! Each feature must be adjusted continually to get along with the rest. So never try to finish one part before going to another.

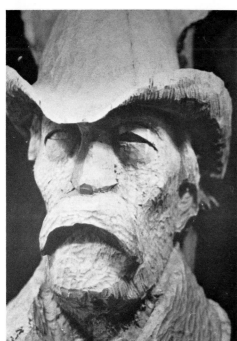

Figure 88

Figure 89

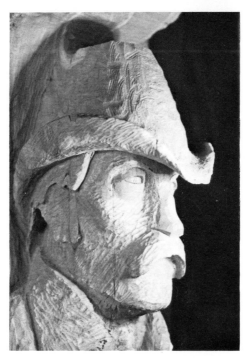

Figure 90

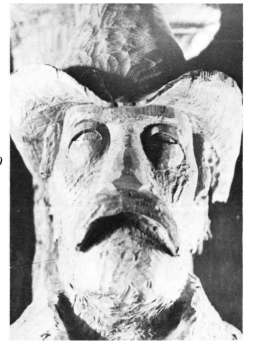

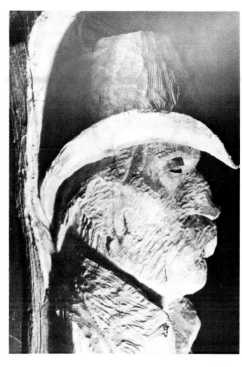

Figure 91

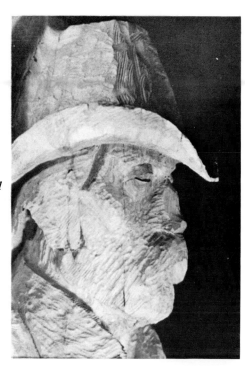

Figure 92

His nose is out there about like mine and we can't have that, so I'm going to trim it to this shape and size (Figure 92). Your guy may want his a little different. Cut those ugly sides off and narrow it toward the front. About as you see in Figure 93. The nostrils need to be showing above the mustache, so make this cut on each side of the nose (Figure 94).

Make this cut on the angle shown in (Figure 95), adjusting to this angle around the top of the mustache (Figure 96). Slant the side of the nose up to the cut and round it front to back, then cut straight in on the top of the mustache. Cut deeply. We want quite a groove here (Figures 97 and 98). Cut the groove straight down to the bottom of the chin.

Cut inward and upward on the line in Figure 99 and straight in around the bottom of the mustache.

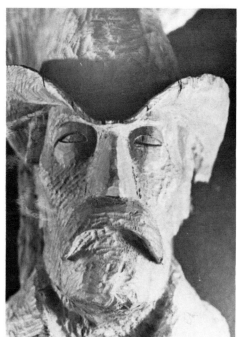

Figure 93

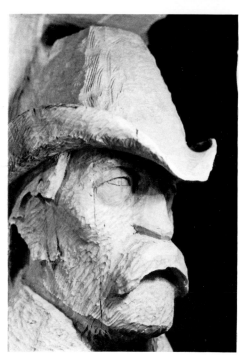

Figure 94

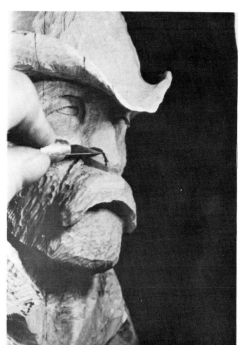

Figure 95

Use a tender touch around the ends of the mustache — they can be broken off. When you have trimmed to the cut all around, it should appear like this (Figures 100 and 101). Don't try to form a lip; it is covered by that hay under his nose anyway. **Wouldn't he look ridiculous eating an ice cream cone?**

Cut a groove in the center of the mustache and slope the ends to the back (Figures 102 and 103). Cut in and back on this line, (Figure 104), and blend the mustache to the face (Figure 105). Narrow the chin in the blackened areas shown in Figure 106, and raise the chin a half inch or so (at least my man's is too long).

Now, we must remove the wood from between the collar and the sides of his neck. Then we can get that jaw line up where it belongs and shape his face like we want it, so we can finish his ears. Cut as

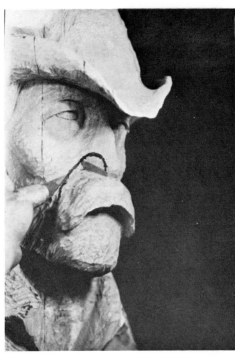

Figure 96

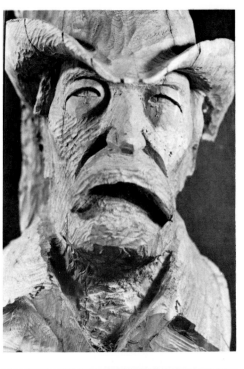

Figure 97

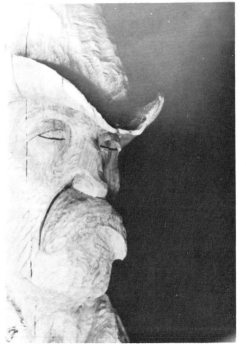

Figure 98

Figure 99

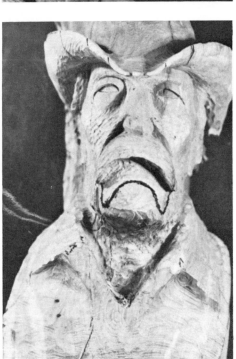

Figure 100

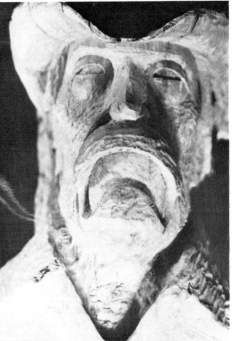

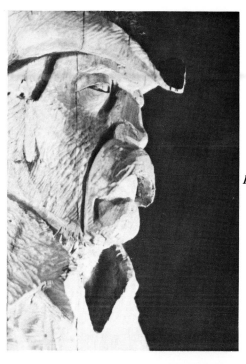

Figure 101

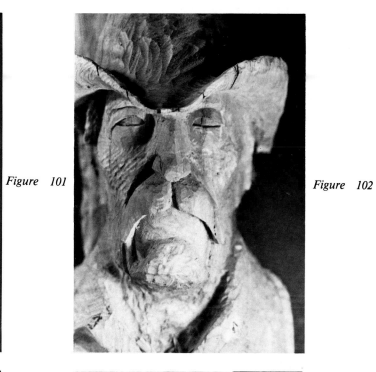

Figure 102

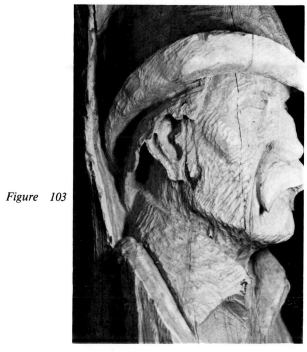

Figure 103

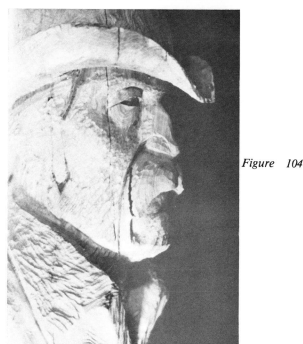

Figure 104

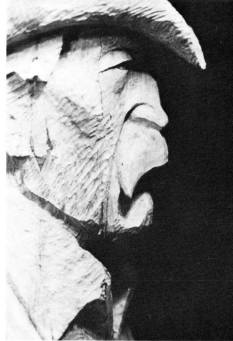

Figure 105

Figure 106

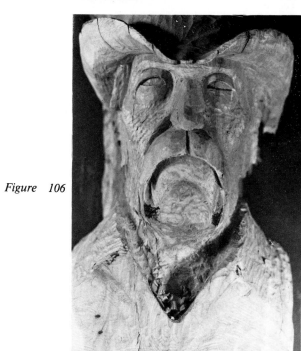

deeply as possible here so the neck disappears inside the shirt (Figure 107). We are still using the ³/₁₆ inch round bit. Go only about as far back as the ears with that tool. The shirt fits tighter there so we will use a smaller bit. In this same operation let's trim the front of his neck, sloping it back on both sides. Make the neck disappear inside the shirt in front as well. Trim his jaw line higher as you go.

Boy, he's getting to be a good looking cuss! Must be from Montana! If we hurry he can catch the last act of the coyote quartet, so let's get busy with those ears. Sketch the inner ear and carve it out like you see in Figure 108. The ³/₁₆ inch round bit works well here. Using your own ear for a model, cut the groove around the outer edge (Figure 108).

Cut a groove beneath his eyes like you see in Figure 109, and another one on each cheek (Figure 110). Being out in the sun as they were, these fellers developed a prominent set of crow's feet at their eyes. Let's get them carved as shown in Figure 111 before we forget it!

Remember the rule I mentioned about **always** carving the head to fit the hat. I lied. Now is the **one** time — after the head has reached the desired width — the hat must be brought in to fit. Yours may not have been as out of proportion as mine (Figure 112). Because we haven't touched the hat since we cut the forehead back to where it belongs, we need to remove some wood from the front of the crown as well. At least mine needs it (Figure 113). There, how does that look? Be sure to maintain the backward slope and round it off nicely. Slant the top of the crown to the back on the line in Figure 113.

With the ³/₁₆ inch round bit, round the back of

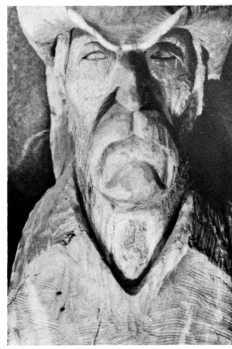

Figure 107

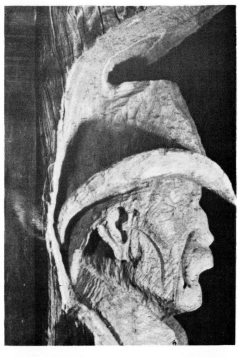

Figure 108

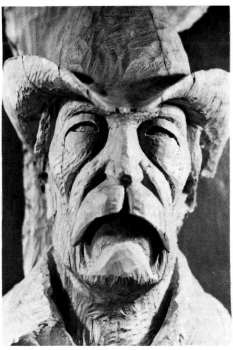

Figure 109

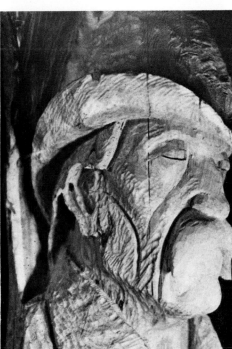

Figure 110

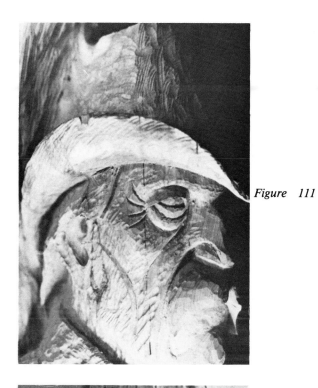

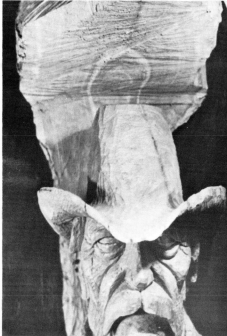

Figure 111

Figure 112

Figure 113

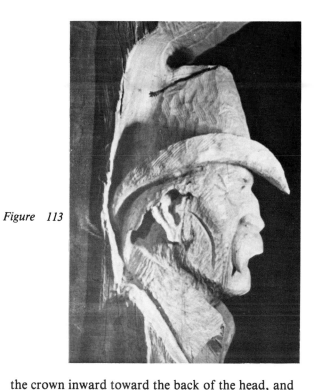

Figure 114

Figure 115

the crown inward toward the back of the head, and clean out all the wood you can reach between the brim and crown at the back (Figure 114). Put a few wrinkles in the brim if you have enough wood (Figure 115).

Let's give that hat some character now, a *lived-in* look if you please. Use your own imagination. **This** style seems to fit **my** man (Figure 116).

We simply **must** get his shirt finished so he can get it off. It needs washing! He's been wearing it ever since we started. Make cuts on each side of the collar as in Figure 117. Leave them that way for a minute, and draw a pocket with a *terbacky* sack drawstring, like this (Figure 118). With the $5/8$ inch rotary rasp take the entire shirt front back leaving the pocket intact, as well as the points of the collar where the last cut was made (Figure 119).

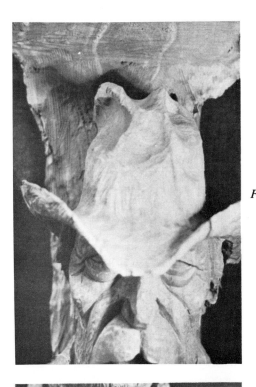

Figure 116

Figure 117

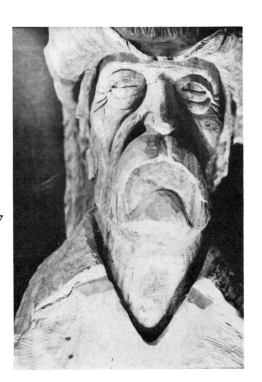

Now, trim those points on the collar, and draw the shirt opening and a couple of buttons (Figure 120). Make a deep cut on the shirt opening and slope it out to the left. Then, cut a shallow groove on the same line. Cut around each button and slope inward to the cut. Force your knife straight in at close intervals all around the buttons. This forms a small groove and gives it depth. Punch two small holes in each one with an awl or similar tool (Figure 121).

Trim the sides and bottom of the pocket — not the top — straight in; trim the shirt flat to the cut, then make a groove on the sides and bottom (Figure 122). What we want to achieve is a pocket with a definite bulge, sagging open, with the string causing the upper edge to fold out and over. The picture may describe it better. Using the $^3/_{16}$ inch round bit, slope the pocket to the sides and bottom, leaving no doubt there is something in it. Carve the drawstring and highlight it with a surrounding groove (Figure 123).

Figure 118

Figure 119

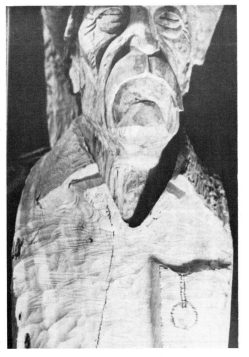

Now, carve out the inside of the pocket with the $^3/_{16}$ inch round bit. Be careful — the edge of the pocket is a little fragile (Figure 124). You needn't go deep — just so it disappears when viewed from the front. You no doubt have noticed I didn't have enough wood on the side of my piece to make a full pocket. But it is **suggestive**, for everyone **knows** the rest of the pocket is **there** — just like we know his shirt continues past the end of the piece and tucks into his pants.

With the same tool, clean out all the wood from beneath the collar. Take it easy and don't go all the way out to the tips, for they come in contact with the shirt front there (Figure 125). Trim the tips out with the knife.

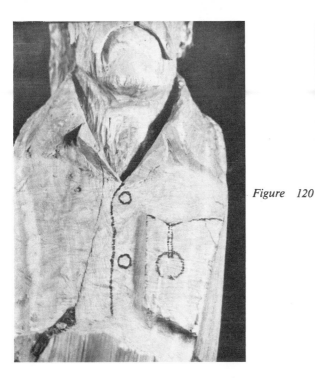

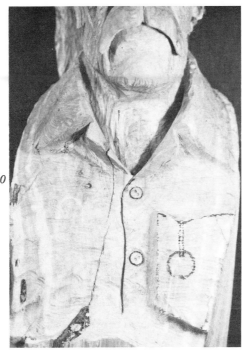

Figure 120

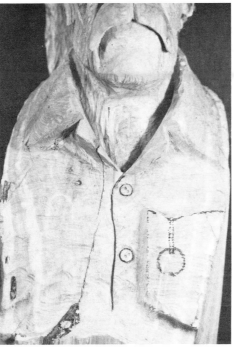

Figure 121

Figure 122

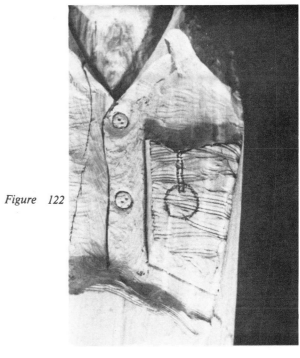

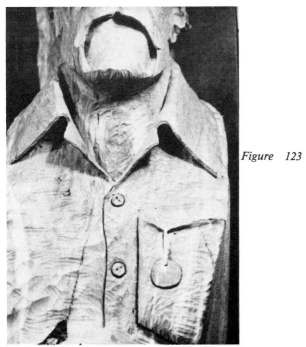

Figure 123

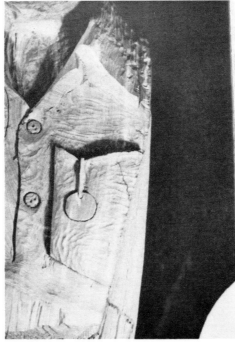

Figure 124

Figure 125

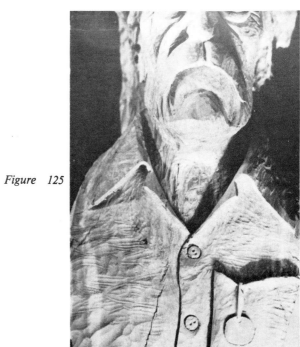

We must remove the rest of the wood from between the neck and collar now. A very small round bit works well here. I use a $^3/_{32}$ inch size but a little smaller or larger one makes no difference. Using a little added effort, the job can be done with a knife. No need to go very deep. Just a nice groove will do (Figure 126).

We have this *poke* blame near ready to talk! What do you reckon he would tell us if he **could** talk? I wonder if he would admit to having apprehensions about the endless miles of waving grass, dotted with thousands of fat cattle, falling prey to the plow. Not that turning the sod was wrong, for he had sat to the *nester's* tables and enjoyed the good food the soil produced. But he had also seen the soil being taken away by the wind and wondered what would happen if millions of acres were turned and left to the mercy of the wind.

And the buffalo — he knew where they had gone, for he had seen the slaughter. He had watched the western movement and seen the cities being built. They called it progress, and he guessed it was, but wondered where it all would end.

We have about five or six little jobs on this old boy and then the finish work can start. First, I should fill some cracks. It has to be done and now is a good time. This is Juniper wood and now and then a crack appears. Cracks should cause no worry, for they are easily repaired. Refer to Appendix I, Repairing Cracks.

Trim his hair inward on a slope above his ears. You can tell when it is about right (Figure 127).

The real cowpokes didn't go in for fancy trappings on their hats, so hatbands were nondescript, if not non-existent. This narrow, plain

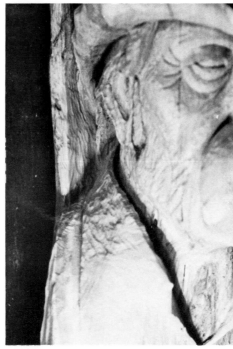

Figure 126

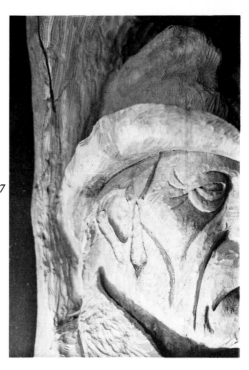

Figure 127

Figure 128

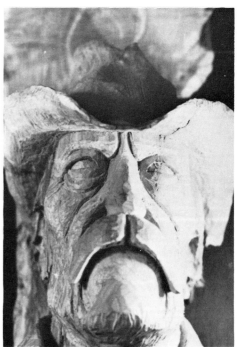

Figure 129

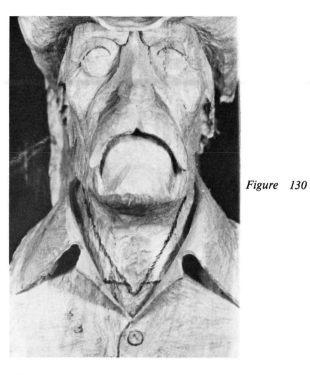

Figure 130

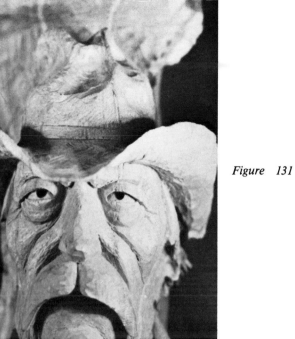

Figure 131

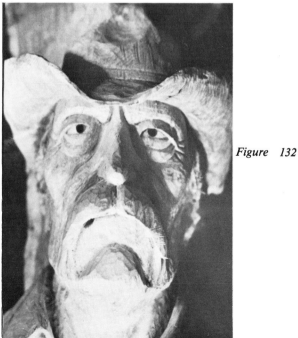

Figure 132

Figure 133

one suits me (Figure 128). Make a deep cut straight in, both over and under, to highlight it.

Before we forget, let's give him a furrowed brow, something like this (Figure 129).

The neck on this feller needs to look more like a neck, so check the mirror and note the hole that is formed where the collar bones meet, and notice the groove just above them. If age is catching up with you, there will also be grooves on the lines shown in Figure 130. Make these features rather prominent. It adds impact. The $^3/_{16}$ inch round bit works well for this.

I like a $^1/_8$ inch round bit for his peepers. Drill a hole straight in, just under the upper eyelid and enlarge it to the point that it looks right — as you see in Figure 131. Leave the hole partly veiled by the eyelid. We will make them a little more piercing when the finish work is done.

With the $^1/_8$ inch round bit, soften the area between the eyes and nose. We don't want those harsh creases there; this area must be rounded inward like a real face (Figure 132).

The hair lines can be made with a number of different tools: a small vee chisel, a knife, a small rotary saw, etc. I like the pointed burr (Figure 133), because it not only leaves the hair with a ragged look but also cleans out the excess wood from between the ear and hair. I also use it to cut the small nostrils that show above that bush. Let's do that now. It's a very simple operation (Figure 134).

Make deep cuts for the hair. We do not want it uniform, so cross over from one groove to the other. I think you can get the idea from Figures 135 and 136.

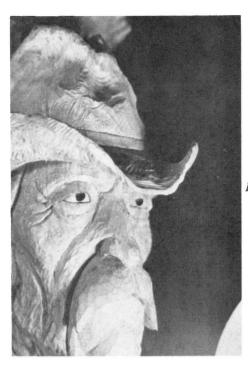

Figure 134

Figure 135

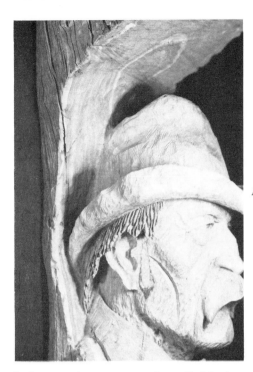

Figure 136

Now, let's get the soup strainer finished. Sheesh! What a mess! Reminds me of the one I shave around every morning (Figure 137).

Carve a *weed* similar to this one (Figure 138). Make it flat on the inner end, cut a hole to fit it and poke it in there. You just took ten years off his life! Don't glue it in till the piece is done — it gets in the way.

We're ready for the last stage — the finish! You may like to use sandpaper. I don't. Most of my finishing is done with riffler rasps. There are many sizes and shapes available. I have settled on the two found in Appendix I. Whatever you use, cover every inch of the person — face, hat, shirt, etc. except, of course, the hair and mustache. Just skim the surface of the shirt. The uneven texture you leave gives it that *wadded-up-in-his-saddlebag* look. I use the small rasp with the three-sided end

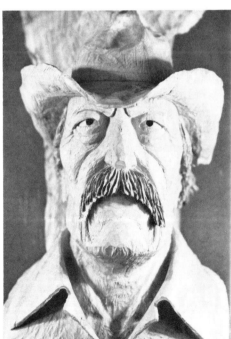

Figure 137

Figure 138

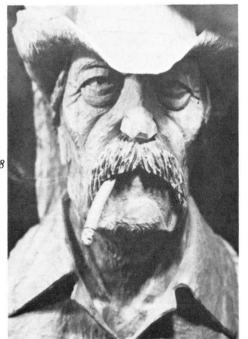

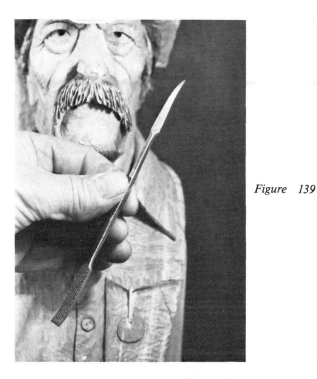

Figure 139

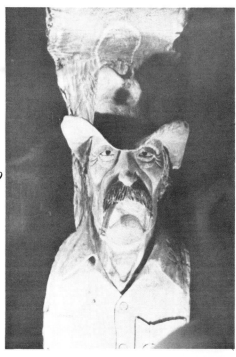

Figure 140

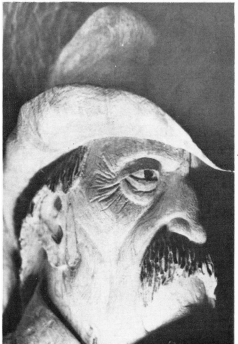

Figure 141

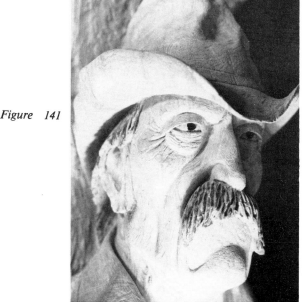

Figure 142

for most of the finish (Figure 139). It gets into all those nooks and crannies so well. The big one gets used when the area is flat.

Leave the uncarved part of the log till later. We will finish it a different way.

Here is the way mine looks with the eyes unfinished. We need to do something special there (Figure 140). The transformation the rasp brings about is remarkable, isn't it?

One more little job and this feller is a person! It's been fun, hasn't it? But get him **done** first **then** brag about it! Let's tackle those crows feet first. Smooth them with the rasp, taking off the rough edges, then with the sharp tip of the rasp make some **light** creases between those heavy ones. We break up the uniformity that way (Figure 141).

Do the top eyelids next. Nothing special — just smooth them lightly being very careful of the outer edge. Finish the bags under the eyes and line them with the rasp like you did the crow's feet (Figure 142). At the bottom of the eyeball, where it meets the lower eyelid, force your knife straight in — making a light groove the full length of the eye. This gives the eye more intensity (Figure 143).

There! Meet the *new hand* (Figure 144), but he won't be just a hand for long. You can see the smarts in this yayhoo and five will get you ten he'll be foreman before the year is out!

There are any number of ways to finish the bare uncarved wood above and below our *man.* Anything will do as long as you remove that unfinished look. A rotary rasp works well. The size doesn't matter. Just go with the grain of the wood

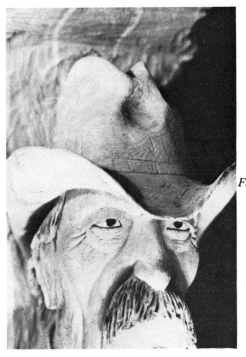

Figure 143

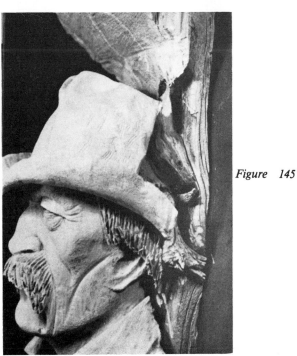

Figure 145

Figure 144

Figure 146

wherever possible, for a smoother look. I like my pieces to have a rough, somewhat wild appearance. If the wood has a flaw where it doesn't detract from the *person* I rarely try to repair it. For example, I haven't shown you the right side of my piece — for a reason. Here it is, Figure 145, and you can see why. Wood is wood and it has character of its own. If that character can be retained with no injustice to the figure you are creating why disturb it?

You are on your own in the finishing of the uncarved wood. This is how I do it but that doesn't mean it's better than any other way (Figure 146).

Upon completion, I soak the piece in Thompson's Water Seal, although the brand name is of no importance — as long as the wood is sealed.

I have tried many finishes and have settled on satin varnish. At least two coats are applied. It must be quite thin for best results.

Other carvers prefer other finishes — tung oil, gun oil, danish oil, Deft, Linseed oil and a variety of stains. Whatever works well for you — but you should talk to other carvers and discuss their methods before settling on any one finish.

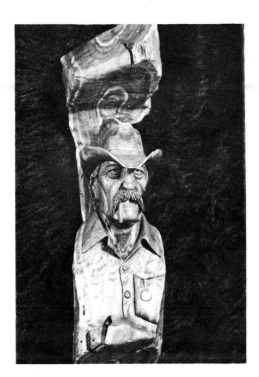

Figure 147

Here is my piece with his finished look (Figure 147). I'm proud of it! I hope you are just as proud of yours.

So, say goodby to Homer — I named him Homer — and I hope you get to visit him again someday.

CHAPTER 2

THE INDIAN

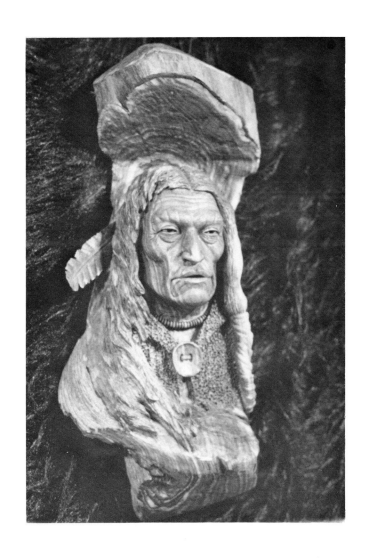

CHAPTER 2
THE INDIAN

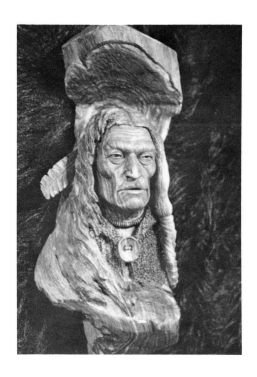

There were many tribes of the well remembered Plains Indians. Each claimed a definite territory, but needed to defend it almost daily. The necessary skirmishes and full-scale wars resulted in new environments for both the conquerors and the vanquished.

But they moved easily, not having to dispose of houses or land. They owned no more than could be transported quickly and easily and all took part in the load carrying, even their dogs. Home was where they **were**, not dependent upon a permanent campsite, for home was the **tribe, the people**.

A happier folk could not be found, for problems within a given tribe were nearly non-existent. The only trouble came from neighboring tribes who wanted their horses or their territory, but this was recreation to them. Battle was the proving ground: where coup was counted, where you gained the respect of every tribal member, where your *medicine* was made strong.

The Indians often adorned themselves with a multitude of decorations. Some were for protection, some for religious purposes, others for beauty. But all adornment was meant to enhance the person. It became a part of them. The bells and beads they wore made music when they moved. The headdresses served to heighten the spiritual atmosphere in which the warriors walked.

I feel the main emphasis should be on the **person** with only minimal attention given to his trappings. Hence, my Indian people remain simple in style, but hopefully forceful in character.

Let's get started!

The piece of wood I am using is 22 inches long and 7 inches wide. The relationship of length to width is of little importance, however, for after due study one finds that nearly any peculiarity can be utilized to enhance the finished product.

This piece is rather oddly shaped, but I intend to use the swirl of the wood for wind blown hair. Your piece may not be fitted for the same configuration, the wind may be blowing from the opposite direction where you live, or not at all. The hair is incidental anyway for we are making a **person**, whatever his hair may look like. All I intend to do is show the basic principles and let your imagination take over where they stop. This piece is deep from front to back, but such depth is not vital unless the character you intend to carve is wearing a broad brimmed hat or anything that requires more wood directly in front.

Never try to take advantage of the full width of your wood if it is a log rather than a sawn piece because the perimeter consists of unstable wood and should be removed. This can be done in the carving process.

All right, do you have your wood selected? Good! Decide which side of the piece the face should be on — free of knots, cracks, etc. Flatten the opposite side as you did with the cowboy (Figure 1). Remove a wedge where the top of the head will be — that can be anywhere you decide, and bevel the ends any way you like (Figures 2 and 3). Clean the face area with a draw knife, heavy rasp or like tool (Figure 4).

Leaving plenty of wood at the sides (to account for the unstable wood) and to allow for the hair, make two lines, as shown in Figure 5, which mark the sides of the face. On my piece the width is four

Figure 1

Figure 2

Figure 3

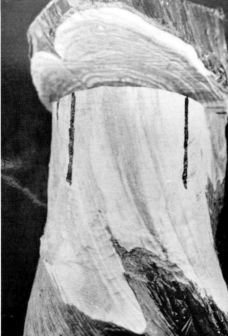

Figure 4

Figure 5

inches. You may need to move the face to one side or the other to utilize more wood for hair. I moved mine slightly to the left because the braid, which needed a tad more depth, will be blowing to the right.

Since the Indian face was somewhat shorter and wider than the Caucasian, multiply the width by 1.5 to find the length. This is a little long but we need some extra on top for hair. Make a mark and draw in, sloping inward to the chin (Figure 6).

Carving the Indian will be much different than the cowboy. And why not? They were different people and viewed the world through different eyes. The Indian gave no thought to *making a living*, for there was nothing to pay for. They simply used what mother earth had to offer. And used it well, I might add! Their way of life was simple and free,

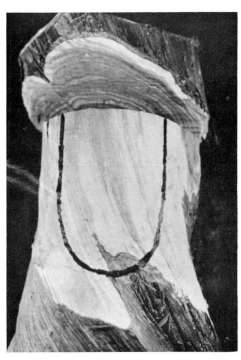

Figure 6

Figure 7

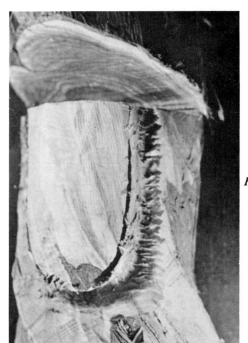

Figure 8

Figure 9

Figure 10

Figure 11

Figure 12

Figure 13

and in my opinion, never equaled. I sometimes wish that those times had been mine to live in.

With the $^3/_8$ inch straight shank bit remove the wood straight back all around on the face line and continue downward about like this (Figures 7 and 8). Of course this is only a start, but as we stressed with the cowboy, always leave enough wood for everything and carve the entire piece back as a unit.

Using the same tool, slope the sides of the head in, the forehead and chin to the back. Roughly cut, it should look like Figures 9 and 10.

With the $^5/_8$ inch rotary rasp remove the unstable wood left on the face area and smooth the entire front of the piece (Figure 11).

The wind is blowing on the prairie and it shows in the way this Crow warrior's hair is whipping. He chose to wrap his hair only on one side today and it is flying in the wind on the other side (Figure 12).

Take away all the wood that isn't hair from the chin down about like so (Figure 13). Notice that he is wearing a buffalo robe held together in front by a shell fastener (Figure 14). The shaded areas are the overlap of the robe. Leave them at their present level for now. With the $^1/_4$ inch straight shank bit remove the wood from between the robe lines and beneath the chin. Go no more than $^1/_2$ inch deep (Figure 15). Smooth the neck area and put one strand of beads on him (Figure 16). Using the same tool remove the wood above and below the beads, no more than $^1/_4$ inch deep — we will adjust it later with a different tool.

Leaving the shaded areas and the shell, remove the wood from the rest of the front. Do not go as deep as the cut below the chin because we want the

Figure 14

Figure 15

robe gaping open with the neck disappearing beneath it (Figure 17).

He would like you to take special care when cutting on his buffalo robe. It has been his cold weather garment for many moons. He remembers well how it became his.

Even though the buffalo was an intermediary through which the Great Spirit could be addressed, the huge beasts were life to the Plains Indians. Almost everything necessary to daily living came from these massive beasts. So the bison must be killed — not wantonly, but only as necessary.

His arrow had found it's mark but in a way he had not imagined. The old bull had turned on him in the heat of the chase — swung the massive head around and up, and went on by with a patch of skin from the horse's belly flapping from a horn. As the great head swept past, the hunter had loosed an arrow, having no mark at which to aim. The behemoth dropped and shuddered and lay still, with half the arrow still visible directly in his ear. All of the kill went for the use of the entire tribe — except the hide — it was given to him as his prize for a feat no other warrior had ever accomplished.

We want to create the illusion that the rest of his braid is behind his back. From the side draw it on something like this (Figure 18), as best your wood will allow. Leave a shoulder line if you have enough wood. You can tell about where it should be. With one of your straight shank bits, remove the wood straight in from the side on each line (Figure 19).

Let's put the ³⁄₁₆ inch round bit in the machine now and remove the wood from the inside edge of the braid on this line (Figure 20). Also, on the other

Figure 16

Figure 17

Figure 18

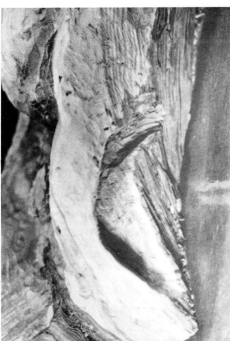
Figure 19

side, between the face and blowing hair, slope the collars of his robe to the back while you are there. All this area will need to be taken back more when we have the face as we want it (Figure 21).

Mark the eyes half-way between the **top of the head** and the **chin** — the nose well above half way between the chin and the eyes. Draw in up and over the eyes (Figure 22). We want to create quite a hole where the eyes will be — deepest next to the nose. This, of course, becomes less deep as we slope the nose and forehead to the back.

Using the ⅝ inch rotary rasp, make the hollows for the eyes, continuing down the sides of the nose, sloping the face to the back. Take only a little wood from beneath the nose for now (Figures 23 and 24). Then the nose and forehead — slope them back on about the same angle (Figures 25 and 26). Notice

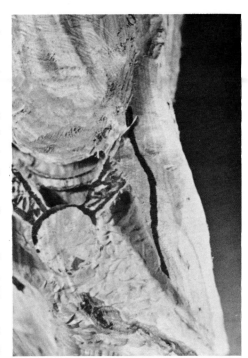

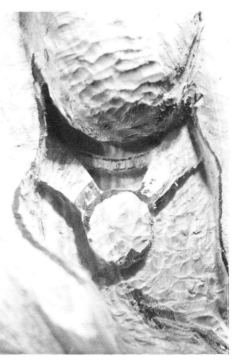

Figure 20

Figure 21

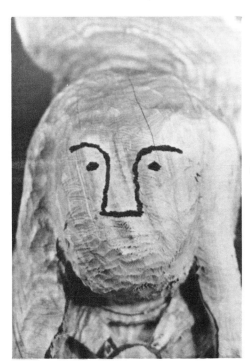

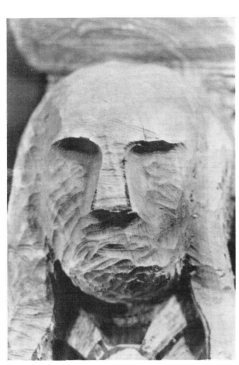

Figure 22

Figure 23

Figure 24

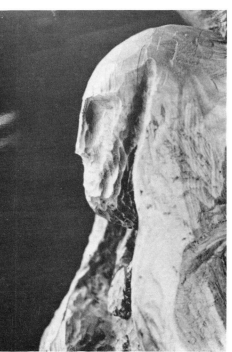

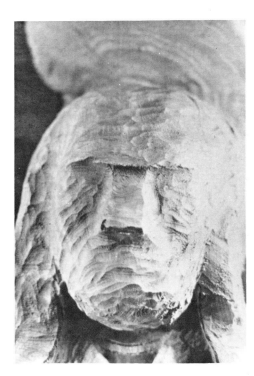

Figure 25

the oval shape of the face. This was characteristic of many Indian tribes.

Slope the sides of the eyes and forehead to the back and take more wood from the entire forehead up to the hairline in Figure 27. It should look like this now (Figures 28 and 29). Go ahead and part his hair with the $\frac{3}{8}$ inch straight shank bit and give him a definite hairline (Figure 30).

I like the way this warrior is shaping up, don't you? I call him a warrior for that is what he is. No longer is he just a brave, for he has counted many coups and this has made him a warrior. A coup was accomplished when the enemy was touched either with the hand or anything held in the hand, and was more important and more daring than the killing itself. The counting of many coups gained the warrior stature and prominence in the tribe. He was

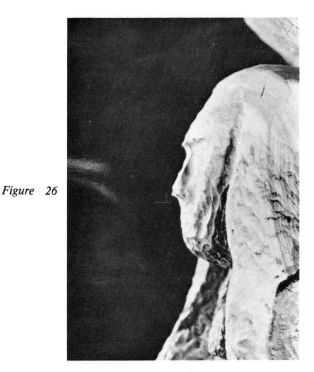

Figure 26

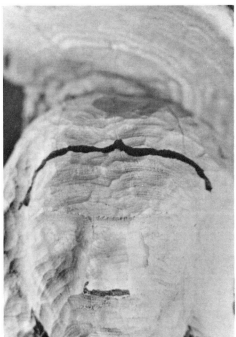

Figure 27

Figure 28

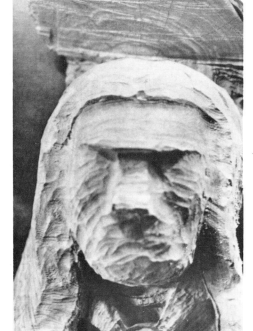

Figure 29

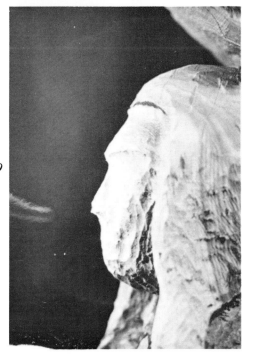

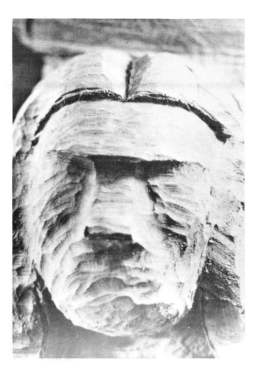

Figure 30

Figure 31

Figure 32

Figure 33

looked upon with awe by the young boys. His council and leadership were requested because his medicine was especially powerful and because the social standing of others was strengthened by their association with him.

With the ³/₁₆ inch round bit, remove the wood where the eye is deepest next to the nose and down the side of the nose, narrowing the bridge like this (Figure 31).

Every detail of our Indian must be fitted to his **face** — unlike the cowboy and his **hat** — keep that in mind throughout the entire process. Cut the nostril area on a bevel on both sides of the nose as in Figure 32, then slope the sides in, all the way to the brow (Figure 33).

Draw a line on each side of the nose as you see in Figure 34, and cut inward on the angle of the

Figure 34

Figure 35

Figure 36

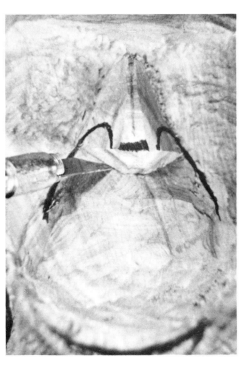

Figure 37

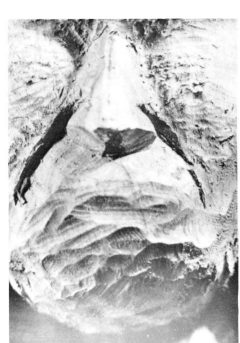

Figure 38

Figure 39

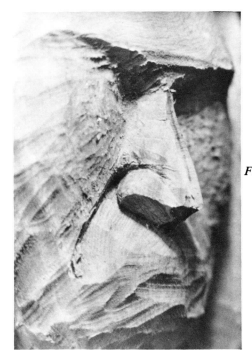

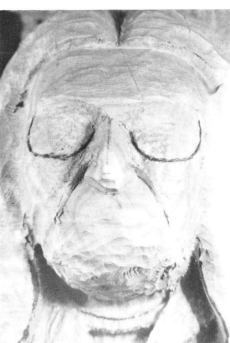

Figure 40

knife (Figure 35). Follow the line on around, adjusting to the angle the knife shows in Figure 36. Now, cut straight in, as the knife shows in Figure 37 and all the way down under the nose to connect with the cut on the other side. Trim the oval on the side of the nose up to the cut. Check the mirror — it will help in this area. Trim the sides of the mouth area back to the cut, up into the hole beside the nose and around the oval on the nose to disappear at the back when viewed from the front (Figure 38), and as seen from the side (Figure 39).

Draw the ovals in Figures 40 and 41 and cut inward and upward all around the lines. Then bevel the eye area downward and inward to the cut all around. Leave the top of the eye as it is for now (Figures 42 and 43).

Draw a couple of peepers about like this

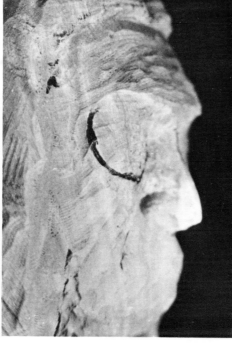

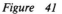

Figure 41

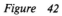

Figure 42

Figure 43

Figure 44

(Figure 44). Be sure each eye is the same width with both inner and outer corners even across.

Hurry, though, for he has been thinking of taking a wife and he needs to **see** the beautiful maidens. He has counted coup and is past the age of twenty-five so is qualified by tribal law to marry. He knows what he must do. It is law in his tribe to be sealed to his wife by blood — their own — accomplished by cutting thumbs of each and tying them together for a time, thus mingling their life blood. Strange to us, perhaps, but who can say how a man and woman are to be united except the society in which they live?

Use a number eleven blade inside the eyes if you are carving with an Xacto knife. Remember the cowboy and make several light cuts around the perimeter of each eye, then cut them out deeply to add impact (Figure 45).

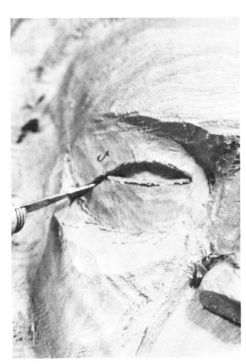

Figure 45

Figure 46

Now cut this line on the angle shown in Figure 46. Then, starting here (Figure 47), go down and around the bottom of the oval on this angle (Figure 48) and connect with the first cut. Beginning with this cut (Figure 49) trim the lower lid downward and inward to the cut at the bottom of the oval. Trim all around, sloping the lid inward at the bottom (Figure 50). Notice how the lower lid was given a more pronounced curvature from side to side. Now trim the top lid in on the outer end to the same oval (Figures 51 and 52).

The process of shaping the eyes has caused his head to grow too wide. This happens every time I carve a new face! As has been mentioned before — each time you take away enough wood to shape one feature you distort another. It is one of the fundamentals of wood sculpture — keep all parts as closely in proportion to every other part, as

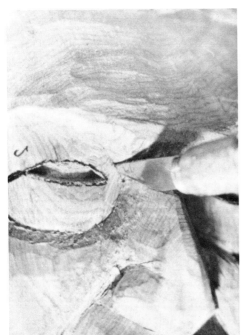

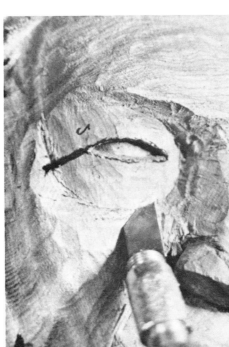

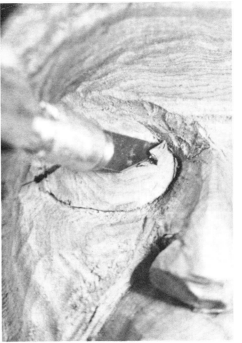

Figure 47

Figure 48

Figure 49

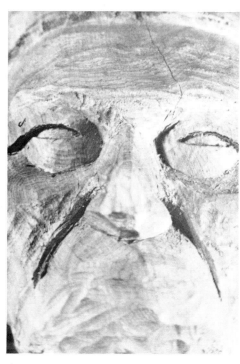

Figure 50

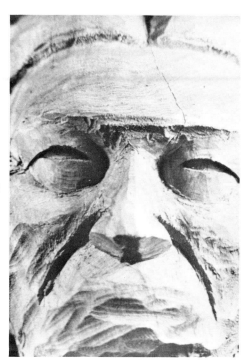

Figure 51

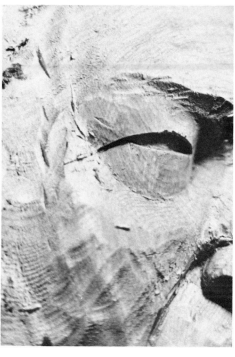

Figure 52

best you can, from start to finish. Now that we have the eyes about as we want, let's do a little head shaping. The best tool for the job is the knife.

Leaving the cheekbones on the sides of the head as they are for now, narrow the temples about like this (Figure 53) and slope the sides of the forehead inward toward the center.

We need to remove that excess wood beneath the eyes and next to the nose. I will use the $3/16$ inch round bit here. Go right on down beneath the cheekbones, leaving them quite prominent as is characteristic of our Indian brothers. Of course the cheekbones are much too wide at present, but let's leave them alone for a minute. Remove the wood from between the face and hair below the cheekbone, so we may establish his jawline. The hair will be touching the cheekbones, so we must wait until the width of the face at that point is

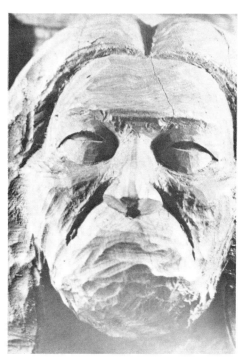

Figure 53

established to know where the hair should be. Wow, the reducing plan worked well, don't you agree (Figures 54 and 55)?

I'm sure your piece looks somewhat different than mine at this stage and it will look different when finished — possibly better — but that is the beauty of wood carving. You simply **cannot** make two pieces alike, and this gives each one a beauty that can be claimed by none other.

Now everyone needs a little depth, but width we do not need. Let's trim those cheekbones in a bit. Be sure they are equal distance from the nose. Uniformity in cheekbones has always been a problem with me, but I have found if I turn the piece upside-down the result is a surprise. Try it! Cut a deep groove between the face and hair in the cheekbone and temple area. It adds depth to the face (Figure 56).

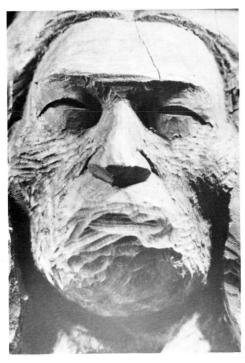

Figure 54

Figure 55

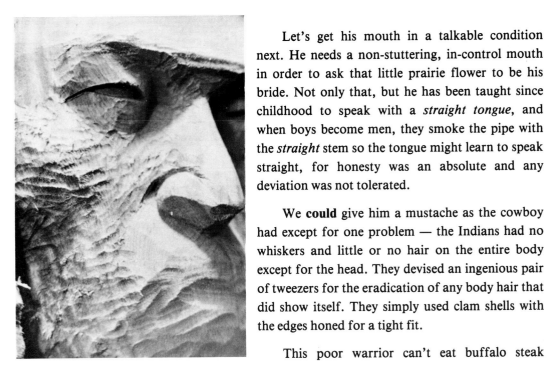

Let's get his mouth in a talkable condition next. He needs a non-stuttering, in-control mouth in order to ask that little prairie flower to be his bride. Not only that, but he has been taught since childhood to speak with a *straight tongue*, and when boys become men, they smoke the pipe with the *straight* stem so the tongue might learn to speak straight, for honesty was an absolute and any deviation was not tolerated.

We **could** give him a mustache as the cowboy had except for one problem — the Indians had no whiskers and little or no hair on the entire body except for the head. They devised an ingenious pair of tweezers for the eradication of any body hair that did show itself. They simply used clam shells with the edges honed for a tight fit.

This poor warrior can't eat buffalo steak

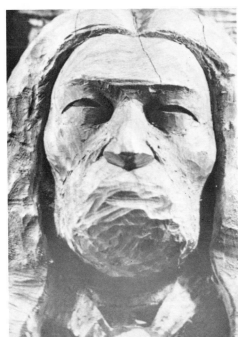

Figure 56

Figure 57

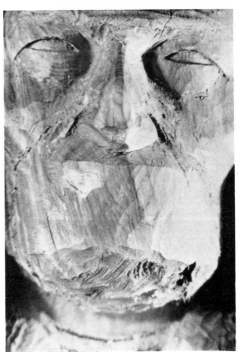

Figure 58

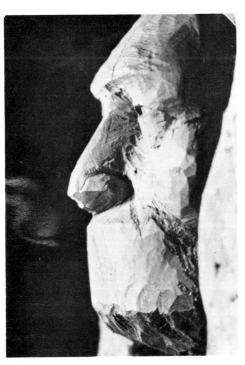

without a mouth, now can he? Nor holler! Nor spit! Let's hurry!

Using the knife, cut the mouth area back considerably, rounding it from side to side (Figures 57 and 58). The mouth reveals the mood, whether happy, sad or angry. A wood carving can laugh, cry, show astonishment, fear or any other emotion. The successful wood carver must learn to put feelings and personalities into his people. An enemy tribe has just staged a successful horse raid upon his people, and he stands frustrated and angry, yet with a determined *I'll-be-over-to-see-you-guys* look.

Draw a straight line across about three fourths of the way up between chin and nose. Put it closer to the nose than you think it should be because the nose must be shortened later. Extending the line to the center of each eye is wide enough for now, being very adjustable (Figure 59). Cut deeply straight in on the line and bevel the lips inward (Figure 60). **Good grief!** How would you like to be stuck with a kisser like that?

On the line shown in Figure 61 cut upward, as the knife shows, below the mouth and at this angle on the sides of the mouth (Figure 62). Now carve the mouth area inward to the cut as in Figure 63.

The mouth and chin require a lot of tinkering, so be prepared to spend some time here. First of all, cut inward and upward around the end of the nose, and trim the upper lip inward on a slant to the nose (Figures 64 and 65). Notice that the upper lip protrudes to the front more than the lower. That's the way we want it! Remember, all faces are different, so nearly any variation from what is shown in this book tends only to make a different individual and does not detract from the basic

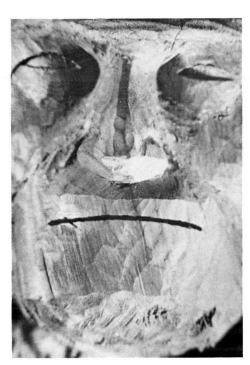

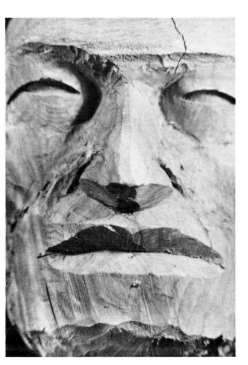

Figure 59

Figure 60

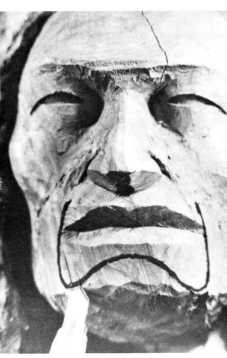

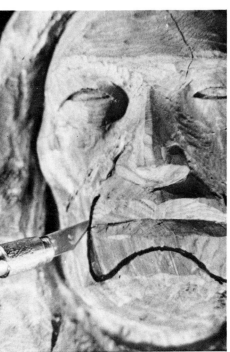

Figure 61

Figure 62

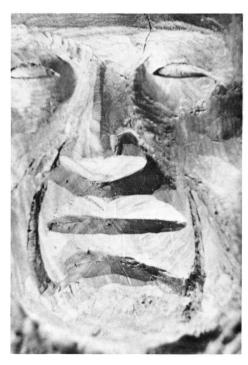

Figure 63

Figure 64

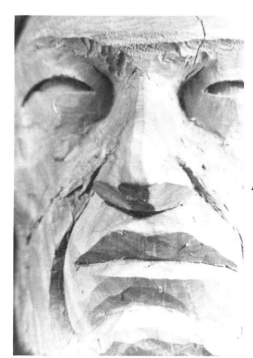

Figure 65

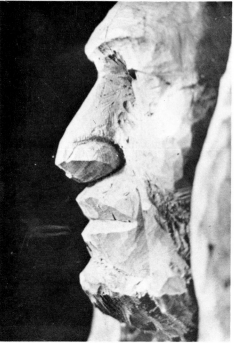

Figure 66

Figure 67

principles set forth.

He should keep his chin up, right, so let's help him all we can. I think I'll use the ⅝ inch rotary rasp as far under the chin as it will go and finish with the ³/₁₆ inch round bit. We are getting his jaw line set so we can finish the face. This is close to right (Figures 66 and 67).

With the ³/₁₆ inch round bit again (would you believe it might be one of my favorite tools) hollow out his cheeks just behind the creases at the ends of the mouth. Go upward in front of the cheek bones as well as beneath them. Slope the jaws back and outward so they will be wider than the cheekbones where they end. But we cannot **see** where they end so they must be narrower where they **disappear**, creating the illusion that they **will** be wider where they **do** end beneath the hair. I'm not even sure **I** understand that! Anyway, try to get the effect in

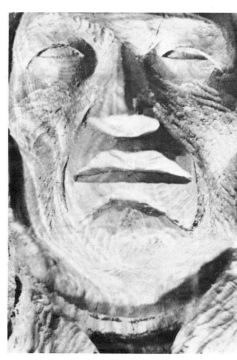

Figure 68

Figures 68 and 69.

He has a feeling of contempt for his enemy, so let's make his mouth reveal that emotion. Turn the left side down sharply to the groove and the right side up just a little (Figure 70). Now let's open his mouth a tad. Open the top lip about like this and cut straight in on the bottom lip. Something like this (Figure 71). In order to make the lower lip disappear inside the mouth, cut inward and downward on the inside edge of the lip. Clean the hole out as far as you can. Adds a touch, don't you think?

The lower lip on most folks disappears beneath the upper at the ends. Both must fold inward at this point with the upper protruding the most. Perhaps I am too technical, but the mouth is **so** important. If you would know the mood of a person just look at

his mouth. It speaks volumes without saying a word!

Study someone's face or the mirror very closely and note how both lips slope backward from the center, then come back toward the front as they near the ends. Notice the darkened areas in Figure 72. They must be *dished* in slightly. Not everyone's mouth looks like this (Figure 73) but it is a good general rule to follow.

We need a deeper groove between the lower lip and chin, and on around where the groove dips downward on the sides of the chin. Leave it alone where it hits the mouth. Trim and round the chin, sloping it to the back at the bottom. Smooth those heavy creases at the sides of his mouth. This is how mine looks now (Figures 74 and 75).

Figure 69

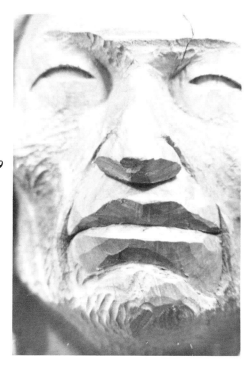

Figure 70

Figure 71

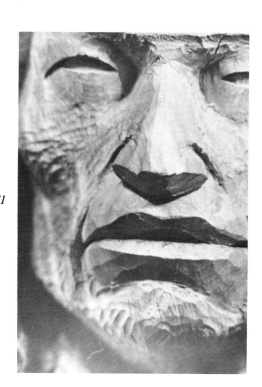

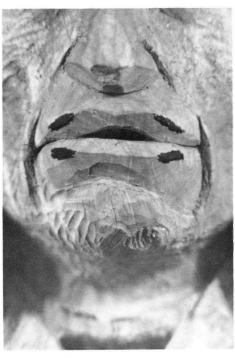

Figure 72

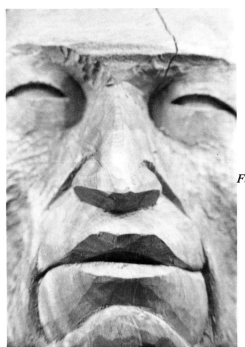

Figure 73

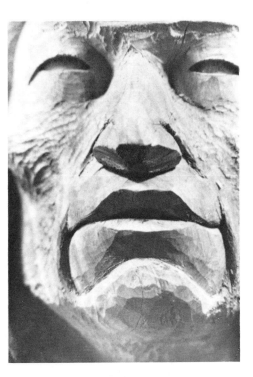

Figure 74

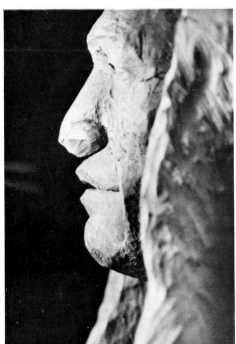

Figure 75

As we have made the face narrower the nose has grown steadily longer. I hope I have gotten the point across as to how this happens. But I will say it again — the bigger nose fit the bigger face but now the face is smaller and the nose isn't. This is the reason for carving all the parts as closely in unison as possible.

Trim the nose up to about here. Mine needs to have the tip rounded a little, too (Figures 76 and 77). Let's trim that brow a tad and slope it back more toward the sides. Do we look about the same there (Figure 78)? With the ³/₁₆ inch round bit make a light groove where the eyelid meets the brow, as you see in Figure 79, and trim the eyelids back to it (Figure 80).

With the same bit, make a groove on the lines in Figures 81 and 82, and slope the forehead back from the groove to the hair (Figures 83 and 84).

Figure 76

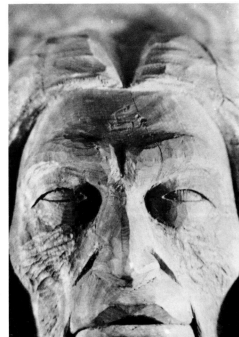

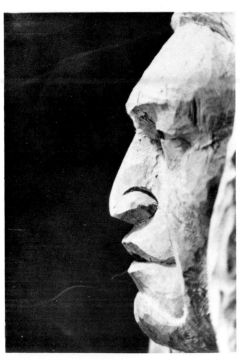

Figure 77

Figure 78

Figure 79

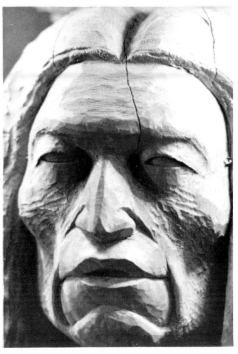

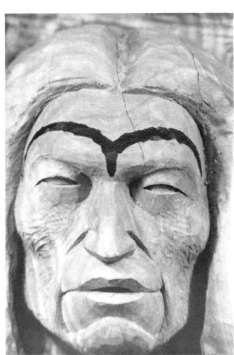

Figure 80

Figure 81

Figure 82

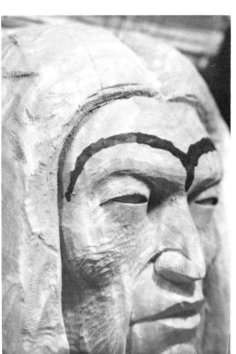

Figure 83

Figure 84
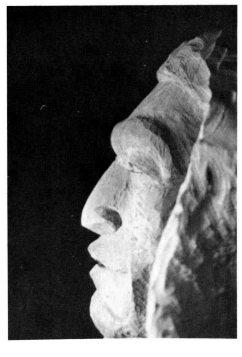

Figure 85
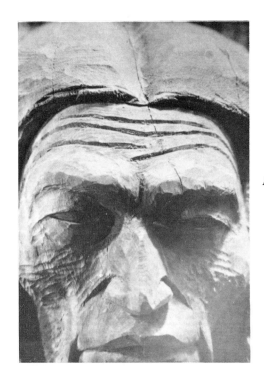

Figure 86
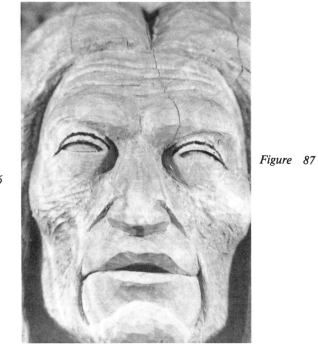

Figure 87
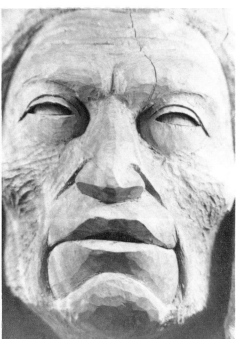

Trim the brows up nicely with the knife and put a few wrinkles in his forehead. Something like this (Figure 85). You can see he's worried about those horses.

Put some marks on his eyelids as I have mine (Figure 86). Cut straight in on the lines and trim up to the cut, leaving the lower edge as it is (Figure 87). I'm going to trim the eyeballs in a bit. It adds intensity. Yours may need it too. Better use a number 11 blade. And yes, Indians had bags under their eyes. Give him a pair and *dish out* the middle part as it shows in Figures 88 and 89.

From a horizontal position again but from the lower end, take a look up his nose. What I mean is look at the end of his nose where you would look up his nose if there was anything there to look up! **Good Grief!** Anyway, make both sides uniform for roundness and draw a circle on each side — as in Figure 90. The ³/₁₆ inch round bit works well for this nose job. You don't need to go very deep (Figure 91). At last! His sinuses are clear!

Grooves on these lines will give that face a little more character (Figures 92 and 93). No, he **isn't** a tomcat!

Draw some peepers on those eyeballs about like this (Figure 94), and make a hole there with a small round bit. I like the ¹/₈ inch (Figure 95). By dogies, looks right through a feller, doesn't he?

Well, what do you think? Is he fit to walk a trail with? Would you have faced the enemy with him had it been your lot? Would you have shared your lodge and trusted him with anything you called your own? I would. A supreme thrill would have been to be one of the first to explore the magnificent West. To have mingled with the first

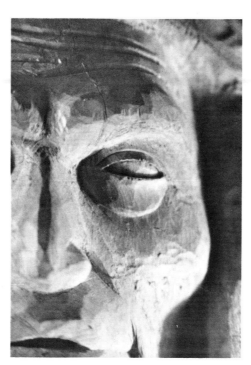

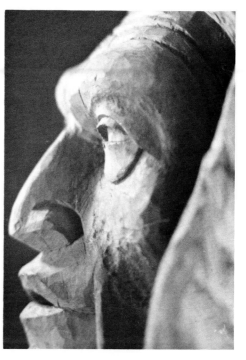

Figure 88

Figure 89

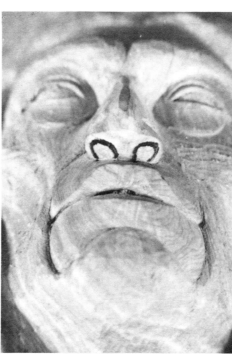

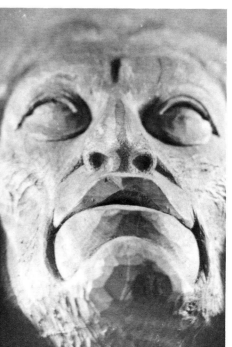

Figure 90

Figure 91

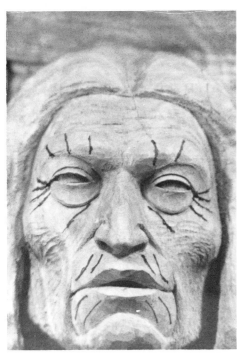

Figure 92

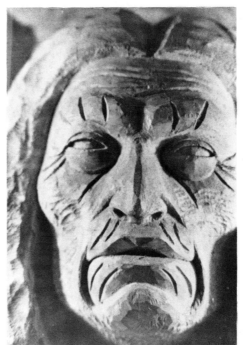

Figure 93

Americans — eaten at their fires and sat in their councils. Melodramatic? Perhaps, but my love for the wild and free has ever been a dominant force in my life. The Indian way of life would have suited me to perfection in my beloved Rocky Mountains.

We need to install that groove on the upper lip that most folks have — the one just below the nose. That ⅛ inch bit should do it. Like so (Figure 96).

He has a face that needs only a little touch-up, so let's get the rest of him in shape! We need to make those beads disappear beneath the robe and the robe beneath the hair. Get rid of all the excess wood back in that hole and slope the neck to the back. Now make the beads follow the neck. Here is what we have to do — the neck must go back far enough to allow the beads to have a groove between

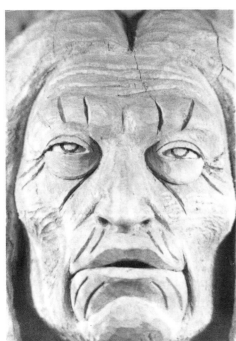

Figure 94

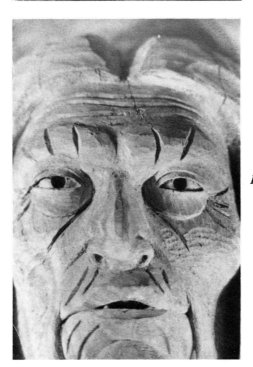

Figure 95

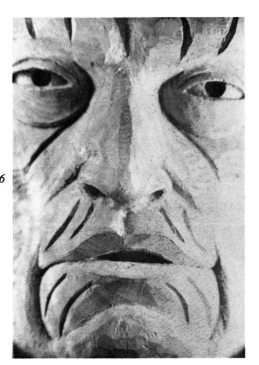

Figure 96

Figure 97

Figure 98

Figure 99

them and the neck, while also allowing enough room for a groove between the beads and robe, yet leaving good depth to the robe. A lot of words, maybe, but if one job is done before the others are ready, it makes a mess. So take the neck back first, then the beads, and make the grooves only when you are sure there is plenty of wood for all. I'll try to get in there for a shot. There, how's that (Figures 97 and 98)?

OK, put the ³/₁₆ inch round bit back in the machine and make the robe collar disappear beneath the shell. Then the robe must disappear beneath the shell all around Make a groove beneath the collar so the robe disappears there. It's a wonder he's still here with all this disappearin' goin' on! This is how mine looks (Figures 99 and 100).

Let's get that braid to looking like a braid. If

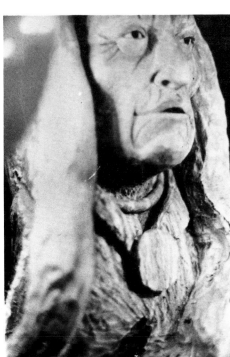

Figure 100

Figure 101

Figure 102

Figure 103

Figure 104

yours is like mine, it needs to be made uniform when viewed from the front. Draw a line across where the top of the wrapping will be and a line down the outside like this (Figure 101). Don't worry about the end — we will turn it inward and make it disappear behind the back. It doesn't matter if yours is different — the carving of it will be the same.

Trim off the sharp edges, and make it round. Don't be very particular with it, because the surface will all be gone in a minute (Figure 102).

Cut straight in on the line at the top of the wrapping, and trim the hair down to the cut. We want the hair to bulge out sharply just above the wrapping (Figure 103). Now some lines to show the rawhide wrapping (Figure 104). Cut straight in on the lines, and trim the wrapping **down** to the cut (Figures 105 and 106). Cut straight in on this line

Figure 105

Figure 106

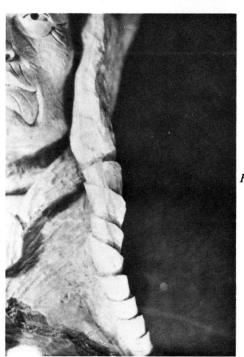

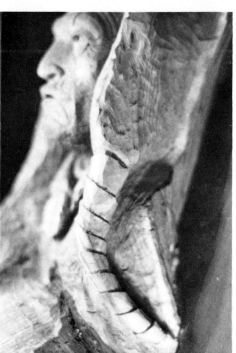

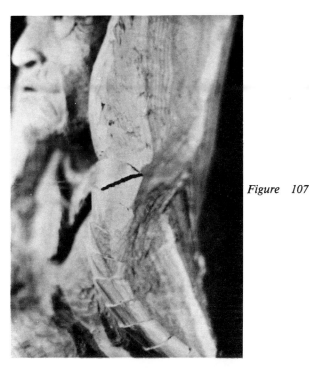

Figure 107

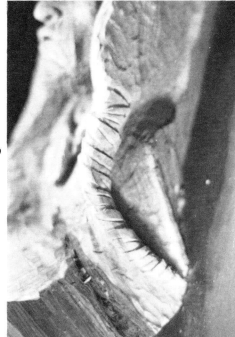

Figure 108

(Figure 107), and trim **down** to it to give the impression the wrapping has been folded under (Figure 108).

The wrapping needs some wrinkles in it. Most any way will do, but here is how mine looks (Figures 109 and 110). I want his hair to have a bulge just above the wrapping and then narrow like this (Figure 111). Give him one of those coiffure things on the right side. This will do (Figure 112).

I'll rough in the hair on the entire left side then take a few shots. I will use the *wood hog* — the $\frac{3}{8}$ inch straight shank bit — for this job, but a smaller one will do just as well. Blowing hair changes every second, so who cares if our pieces do not look exactly alike. All I want is to show you the best way I have found to duplicate blowing hair, and which ever way it turns, the procedure is the same (Figures 113 and 114).

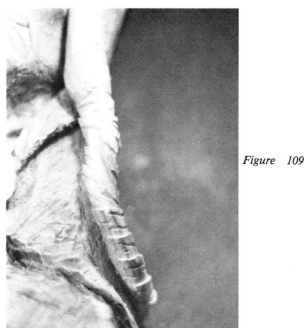

Figure 109

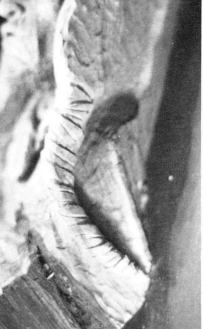

Figure 110

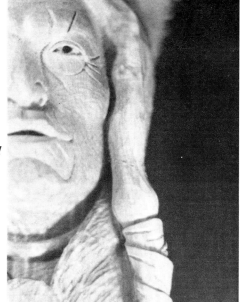

Figure 111

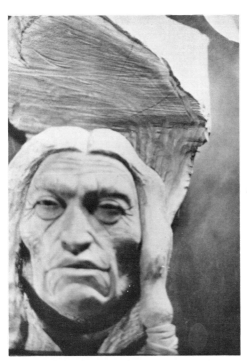

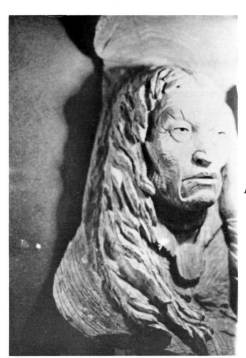

Figure 112

Figure 113

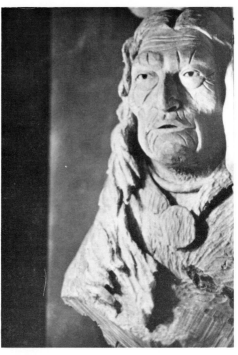

Figure 114

If we had more wood on that side we could make the hair really fly, but the wind doesn't blow that much in Montana, so we don't need it. We could have had his hair blowing across his face more. It could have been wilder on top, but I do not like a piece so busy that it takes away from the person. He has hair and it is blowing in the wind, but not to the point that it dominates the piece.

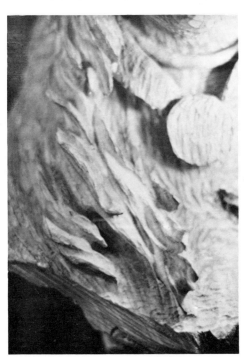

Figure 115

To finish the hair prior to texturing, I like the ¼ inch round bit with the ¼ inch shaft. It will do a much better job, though, if it is **dull**. Why? Because all that needs to be done to the hair is smooth it, not cut it. If you have an old bit, it is probably dull enough, but if not, hold the bit against a file or stone for a moment while it is turning. In the smoothing process, cross over from one groove to another. This gives the hair more movement (Figures 115 and 116). Smooth the other side, too, while you're in the mood.

Figure 116

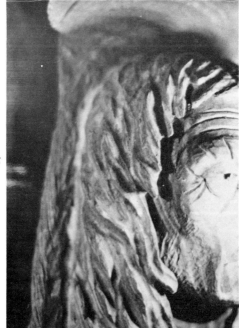

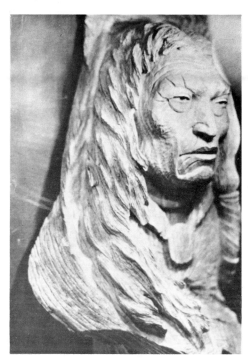

Figure 117

Sometimes I like to leave the hair smooth and flowing as it is now, but let's put some texture in for this warrior, shall we? I like to use a ¼ inch circular saw for this job. Refer to the chapter on tools. The saw will not reach some areas because of the angle, so the ¼ inch drive pointed burr must be used. It leaves a cut that is nearly identical. If a finer texture is desired for the hair, hold the saw blade against a file or stone while it is running, at a slight angle, which narrows the cutting edge. That is what I will use here. I like the impression this leaves! (Figures 117 and 118).

Now that we have the hair out of the way, let's open his robe below the shell using the ³⁄₁₆ inch round bit. Go the same depth as above it. Cut downward as far as your piece will allow. Make it flare open by beveling the robe inward from the edges of the opening, and taking the entire front back to match. Something like this (Figure 119). Don't make his chest disappear under his robe until you have the front finished.

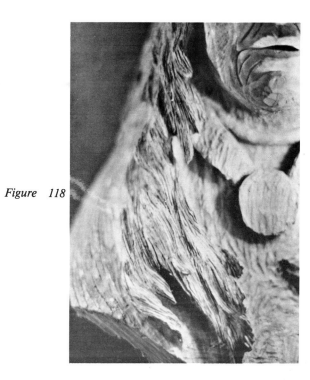

Figure 118

With the same bit hollow out the shell fastener about like so (Figure 120), then cut straight in on the lines of the rectangle, and trim the shell in to the cut all around (Figures 121 and 122). Carve what looks like a hole through the shell on these lines (Figure 123), and taper the ends of the rawhide into the hole (Figure 124).

Have you noticed that Indian maiden lately? She has a shy little grin on her face. She knows her man is almost finished and will come calling shortly.

I have a name for this and it's spelled **exciting**! Whether you decide to pursue the art as a business or just for fun, it is still exciting. We started with

Figure 119

Figure 120

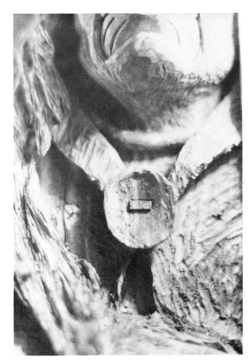

Figure 121

Figure 122

just a piece of wood, remember? We could have cut it into slabs and made cribbage boards. We might have designed a unique jewelry box. A picture frame, maybe? Firewood? But now that piece of wood is a **person** — almost exactly as we planned for him to be, with the right expression and all the parts in the right places. Tell me that's not exciting! And all because we had the patience to get acquainted with this individual as we brought each new feature into reality. Because we took the right steps at the right time.

Why am I saying this before the piece is even done? I just had an itch to say it so I scratched it.

Put a very small bit in the machine, and make small holes in his robe as close together as possible. Don't be meticulous — just poke them in there! (Figure 125) **Wow!** I don't know what you think of that but I like it!

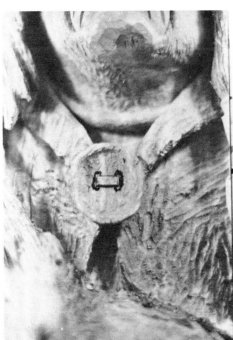

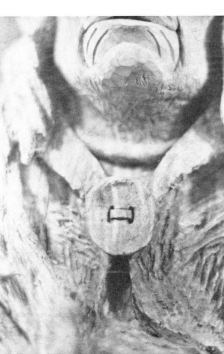

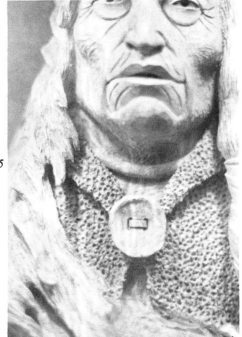

Figure 123

Figure 124

Figure 125

The beads the Indians often wore were fashioned from shell, stone and seeds, to name a few. Our man's necklace is of tiny flat pieces of shale rock. Using the pointed $\frac{1}{8}$ inch shaft bit, make shallow grooves straight in, cutting as far under and over as you can. (Notice the next few Figures) Don't try to make them uniform for they weren't.

I'm going to spend a few minutes narrowing the face a little, making sure the sides are uniform from every angle. Turn the piece every way and study it — upside-down, side ways, horizontal and from each end. Take your time and don't stop until your are satisfied. One of the little jobs we must do is smooth the area between each eye and the nose. The sharp groove makes it a little unreal. The $\frac{1}{8}$ inch round bit works well here.

Here is mine an hour later. It looks only a little

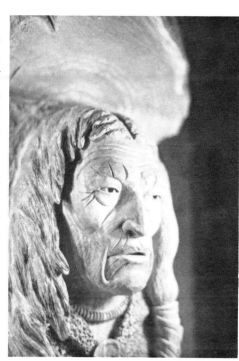

Figure 126

Figure 127

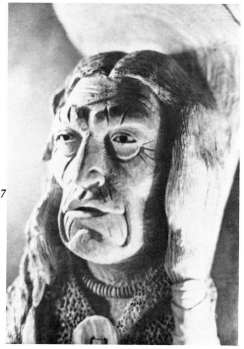

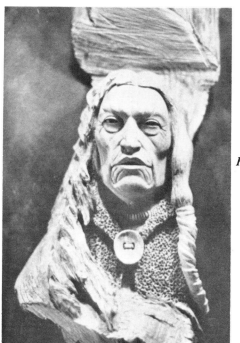

Figure 128

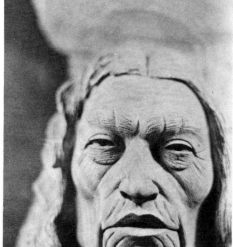

Figure 129

different but much better (Figures 126 and 127). I brought the cheekbones in and sloped them to the back, narrowed the cheeks and the jaws, raised the jawline at the back, raised the chin a tad and shaped the neck. He's the same warrior — just spruced up a bit.

Now the finish! I'm ready, aren't you? Always try to get that rasp to every spot on the piece except, of course, the robe and hair and only lightly on the beads.

There! **I like it! I like it!** Is mine as good as yours? (Figure 128)

Just a few scratches on those chicken tracks on his eyes and on those bags. Use the sharp end of the rasp for this little job. Also a few more scratches for eyebrows (Figure 129).

One last job on the face. Remember how we

made the cowboy's eyes more intense? By forcing your knife straight in between the eyeballs and lower lid. That's better, don't you think?

As soon as you finish the uncarved wood at the ends — any way you like — he is ready to go a-courtin' — except for one thing. That's right, a feather in his hair! The wind is blowing, so the feather must convey that message as well.

Cut the feather to the shape you want, but leave the piece about an inch thick, so it can be given a *bend* from end to end as well as a *twist*. Leave it at least ³/₈ inch thick, for it must have enough wood for the *waves*. Refer to Chapter 4.

My feather making system is no better than the next feller's, but this warrior likes **my** style, so here it is (Figure 130).

To mount the feather, make a groove where you want it about a half inch deep. The ³/₁₆ inch round bit is best for this. Put only a little glue in the hole after turning the piece on the side, so the glue won't take a walk. Hold the feather in place until it will stay then make a paste of glue and fine sawdust and force in all around the feather. It will finish off nicely when dry (Figure 131).

All right, little prairie flower, he is on his way. The gifts that he brings are to be prized, because a suitor in your nation would offer only expensive gifts for a virtuous girl. You should be very proud! Give him love, honor and devotion. Treat him like a king, and in return he will treat you like a queen.

Figure 130

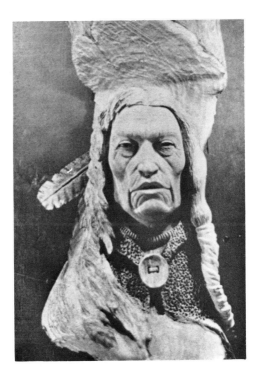

Figure 131

CHAPTER 3
MOUNTAIN MAN

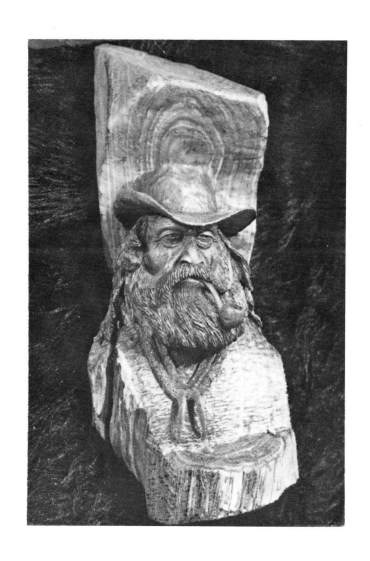

CHAPTER 3
MOUNTAIN MAN

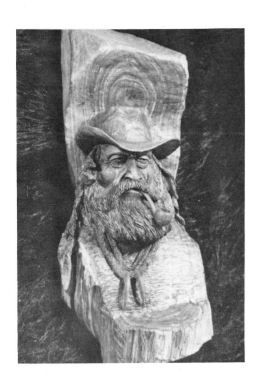

After carving the cowboy and the Indian, you have, no doubt, become well acquainted with the various tools and what each will accomplish. To avoid redundancy I will not be specific as to tool use in the carving of the mountain man. I will only suggest the job to be done and the tool selection will be left to you.

Mountain men were not a breed of dirty, unwashed savages; they were simply men who were answerable to none, afraid of nothing and who had an unquenchable desire to be free from the crush of civilization. They needed only their wits, a steady shooting eye and a healthy love for the morning sun slanting off a mirrored lake. Mountain men were loners because they wanted to be. They knew where the cities were; that's why they stayed away. Lonely? Certainly not! Who could be lonely with the deer and elk to talk to and a squirrel on his shoulder? Such men were not sad, for to live among the pines, to listen to the music of rushing waters, to stand upon the rocky crag and hear the bugle of the proud Wapiti is living as close to the Creator as one can.

Proud men, not to be pitied but envied. They went where they pleased and stayed as long as they liked. Had this old wood carver been born in those times, the mountains may well have been his home.

Mountain men were, for the most part, a happy, contented lot, but this one is still mad as the dickens. You will find out why in a day or so. Just thought I'd warn you. He is standing on a high ridge looking out across his valley, the wind in his hair and his buckskin shirt not quite adequate against the bite of autumn. In winter he would wear a fur headpiece, but until then he likes a hat with a wide brim.

Here is the piece the old boy is hiding in (Figure 1). It's a wild looking thing in itself, isn't it? I have the wedge cut out where the top of the hat will be and the face area smoothed so we can at least see a pencil mark (Figure 1).

The wind is about to blow this feller off the ridge and it has turned his hat brim up on the left side. Since we don't need as much wood there for a brim, let's move to the left of the center just a tad. The crown of the hat is flat and the brim is almost flat, so sketch it about like so (Figures 2, 3 and 4). Draw a line as shown in Figure 5. This will take care of his beard and hair, too. Sure it's too much but that's better than too little, isn't it?

Did you hear **that?** He said, "Stop wasting time and let me out of here — I've got a trapline to run. It won't be but six weeks till the beaver ponds

Figure 1

Figure 2

Figure 3

are frozen over, so hurry, won't you?''

Yes sir, we surely will! Put that *hog* in the machine and get to flingin' wood! Start above the brim and move all the wood inward to the crown as shown in Figure 6. Leave the brim about ½ inch thick all around.

Now, cut the front of the crown back. The brim is turned down only a little here, so this should be about right (Figure 7). This isn't far enough back yet, but it will get more in a jiffy. Remember, we take the entire face back as a unit.

Remove the wood from beneath the sides of the brim next, cutting straight back on the beard line (Figure 8).

Remove a substantial amount of wood from beneath that haystack because his face is just a little too far to the front, don't you think (Figure 9)?

Figure 4

Figure 5

Figure 6

Figure 7

Figure 8

Figure 9

Figure 10

Figure 11

Figure 12

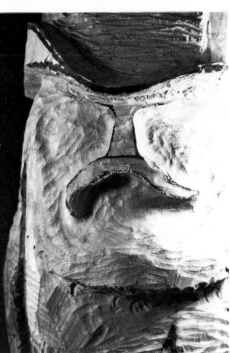

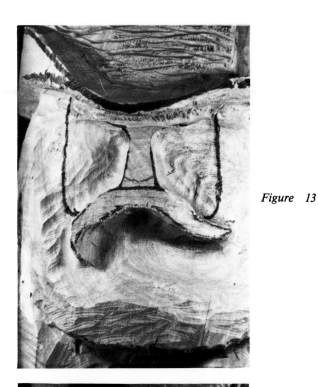

Figure 13

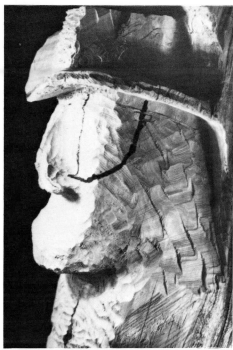

Figure 14

Figure 15

Figure 16

That's enough for now. There is plenty of wood for that bear claw necklace that he wears everywhere he goes — even to bed!

The sun will be mighty tough on this old trapper's eyes if we don't get his face back under that hat brim. The lower end of the beard must protrude to the front, even farther than the nose, so slant the face inward to the top. Remember to leave the hat brim plenty thick. Round the face a little from side to side as in Figure 10. Sketch the eyes, nose and mustache, keeping in mind that the wind is blowing, so the soup strainer must show it on the left side (Figure 11).

We need to form hollows for his eyes as we did with the cowboy and Indian, but the depth should be less than that of the Indian because **his** forehead sloped back more sharply, which reduced the depth of the hollows. Now, continue downward on the sides of the nose and completely around the mustache (Figure 12).

The width of the face at the temples is in the vicinity of three times the length of the nose. For lack of a better ratio let's use this one. Adding a little extra on each side, draw marks about here (Figure 13). Turn them inward at the bottom — this is the beard line. Of course the beard slopes to the back from the mustache to the temple, so make this mark on the **right** side (Figure 14). All of this will need adjusting later, but we have to start **somewhere**. Remove the wood straight back between the lines and up to the brim as in Figure 15.

The left side has a somewhat different hair style due to the wind. I'm no great shakes as a hair stylist, so any variation of these hen scrachins' is OK with me. The flaw in my piece of wood was a

design factor, but you could probably extend the hair more to the front on your piece (Figure 16). Notice the beard line from the mustache upward. Carve it back the same as the right side, only leave the hair (Figure 17). Trim the beard back to the hairline, sloping it in to the face at the top. Remove some wood beneath the hairline all around to the back (Figure 18). Kind of ragged, eh? He would only laugh if you suggested using a comb.

Slope the hair up to where it meets the hat and make it disappear behind the head (Figure 19).

Back to the right side. Make a hair line anyway you like to show the hair is blowing to the back. Staying beneath the hairline, slope the beard inward toward the temple and backward from the chin. Slope the hair inward to the head at the brim while you are there (Figure 20).

Figure 17

Figure 18

Figure 19

Figure 20

I don't understand why he doesn't shave the bloomin' stuff off — it's too hard to make, but if a hunting knife is the only cutting machine you have, I guess it would make for tough shaving. Slope the sides of his face back, extending beneath the hair on the left side, forming a temporary beardline at the temple. This will do for a moment (Figure 21).

With a small bit, rough in the eye ovals, down the sides of the nose, in front of and beneath the cheekbones. Reduce the size of that brush pile under his nose as I did in Figure 22. Of course the mustache will require much more shaping, but we are simply taking it back with the rest of the face.

Clean the wood from beneath the brim at the forehead (Figure 23). Let's get his nose in shape now so he can smell the roses. Make a cut on each side on the angle shown in Figure 24, then trim the sides like this (Figure 25).

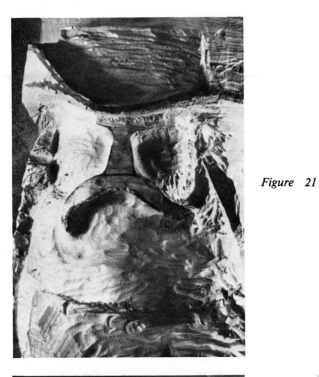

Figure 21

He didn't **have** to fight so much when he was a kid but, good grief, a feller could stand being called *Eagle Beak* just so much. I tend to sympathize somewhat with his accusers though, don't you (Figure 26)?

I need to raise the brows on my guy just a tad and narrow the nose between the eyes and dig those holes deeper. There, little by little — that's the way a sculpture is formed (Figure 27).

True the eye ovals with the knife making them much narrower than the face is now. As before, make certain they are the same in all respects (Figures 28 and 29).

What do you say we fashion the hat? We have neglected it long enough and we need to know where we are going with the head. Narrow the brim from the top side only. We keep it as low as possible

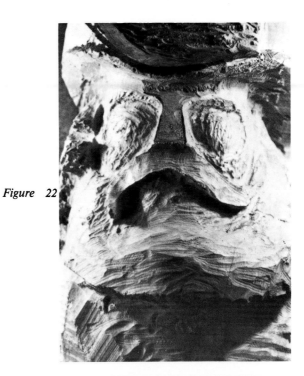

Figure 22

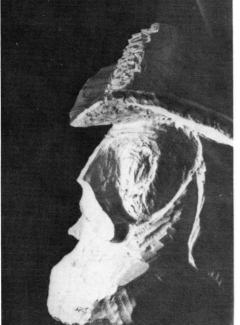

Figure 23

Figure 24

Figure 25

Figure 26

Figure 27

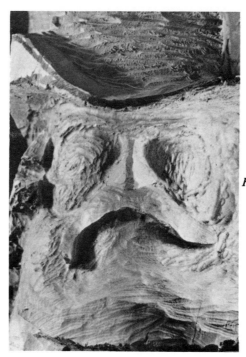

Figure 28

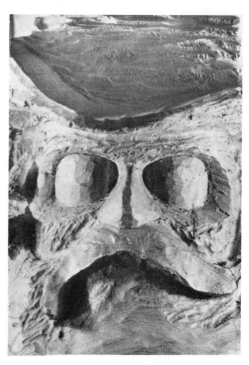

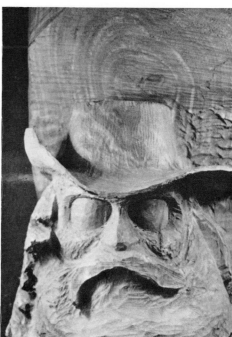

Figure 29

Figure 30

that way (Figures 30 and 31).

He sure has a wierd beard! Maybe it would improve the looks if we trimmed the sides in to the face, took out a bunch below the ends of the mustache and hollowed the area at the sides of the mouth and below the lip (Figures 32 and 33). Leave his lip as it is till later.

We need to narrow his face now. Start with the temples, leaving them only slightly wider than the eye ovals. Slope the temples inward toward the top of the head. Now, get rid of that excess wood beneath his eyes leaving a slight cheekbone. He does his own cooking so doesn't have a lot of meat on his bones (Figure 34).

Take his lower lip back some, but we want it protruding more than normal. He's mad, remember? He also smokes a pipe, so the right side

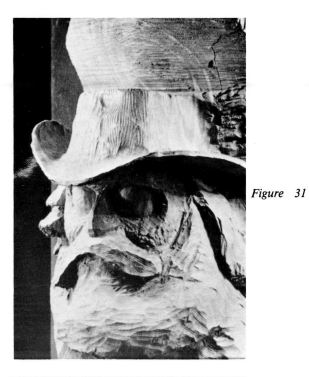

Figure 31

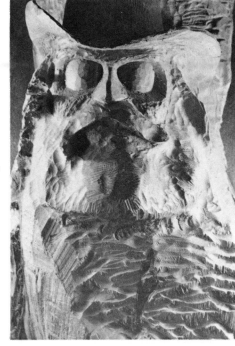
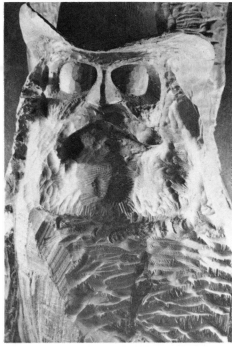

Figure 32

Figure 33

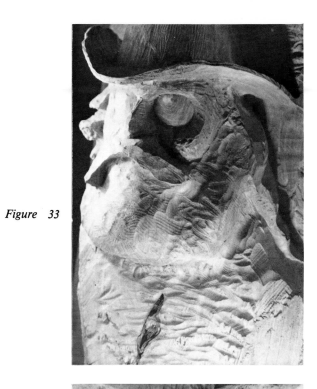

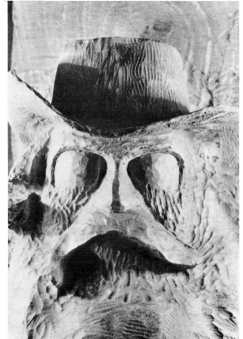

Figure 34

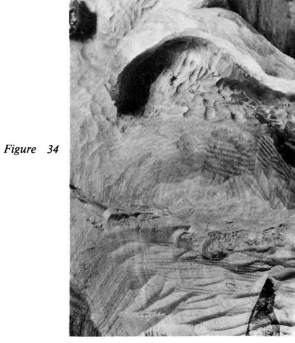

Figure 35

Figure 36

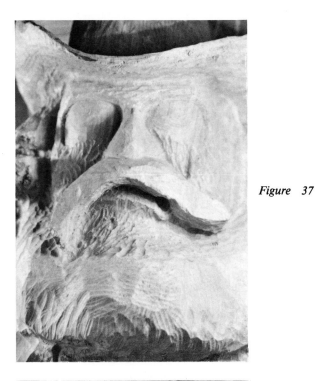

Figure 37

Figure 38

Figure 39

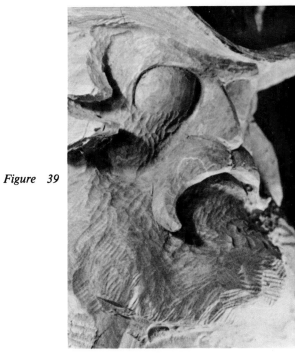

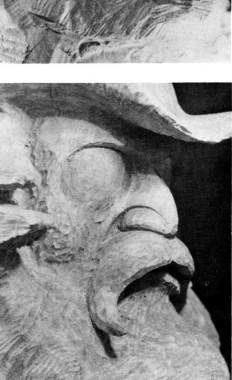

Figure 40

Figure 41

must show that it is pulled downward by the smelly old thing. I tried to omit it but, jumpin' gee whack, I'd rather argue with a *grizzy* bear (Figure 35)! Drill a hole up into his mouth at an angle that a pipe would be held, as in Figure 36, and trim his lip to conform to the hole (Figure 37).

Cut that mustache back a foot or so and give it a little better shape (Figures 38 and 39). Hey, that's nothing but pure class!

If the procedure for shaping the sides of the nose is a little fuzzy in your mind, refer back to the nose job on the other two critters. Figures 40 and 41 show a pretty respectable snoz, I think.

Here's what I did while your back was turned (Figure 42). Rather ragged yet, but I like the way he is coming around. Notice that I trimmed the hair up to the hat, took a substantial amount off the side,

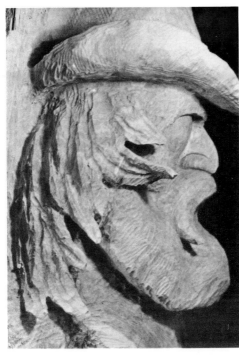

Figure 42

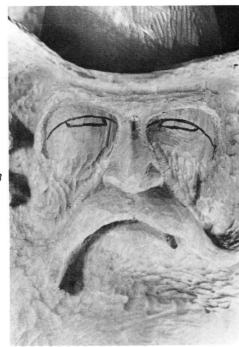

Figure 43

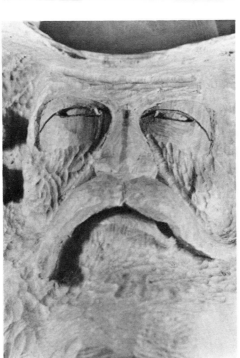

Figure 44

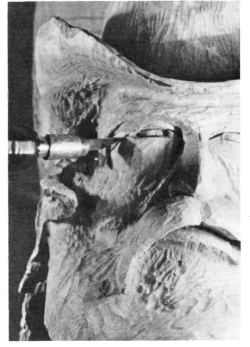

Figure 45

gave it a disappearing act at the back and formed a beardline at the temple when I removed the excess wood from beneath the blowing hair.

You have to be tough to live in the wild and our man is beginning to take on that appearance. Fact is, he's still steamed about those two yahoos he crossed trails with a couple of days ago. He'd cut their sign when he was coming in from his trapline and got an uneasy feeling that it might be good to have a chat with them. He headed cross country and hit their trail just ahead of them as they were slogging across the creek. They pulled up mighty short when he stepped from behind the big fir, his thirty-thirty at ready. "Howdy, boys," he'd said, "what you totin' in the packs?"

"You'd do well to mind your own affairs," the big one had sneered as he started toward him. A bullet smacked the ground at his feet, spattering his legs with gravel.

"Now shuck the packs and open 'em up." There was no nonsense in the order and he flashed a toothy grin when the dynamite spilled out. "I thought so," he growled, "blowing beaver dams is worse than rustlin' cows. I could bury you both right here. I'm not in a killin' mood' but I will be if I see you boys in these parts again. Now, leave the stuff layin' and **Git!**"

This is the kind of feller we're creating so keep those tools **hot**! We're making a **Man** here!

These eyes well befit our *Beaver Man* (Figure 43). As before, make sure of the uniformity from every angle. Use the #11 blade again and cut lightly several times on the lines. Carve the eyes out deeply (Figure 44).

Cut on the angle the knife shows in Figure 45 and, beginning where that scalpel is sticking (Figure 46), cut down and around the oval. Trim the lower lid down to the cut, maintaining the inward slant toward the bottom and increase the side to side oval to fit the eyeballs, as they appear in Figures 47 and 48. When trimming upward to the lower lid, always make the lower cut on this angle (Figure 49) and trim the upper lid inward on the angle shown in Figure 50. Now, trim the upper lid inward all around to fit the lower, leaving the front and center as is. Slant the top lid upward and inward as you see in Figure 51. Notice the contrast between the two eyes. See how much wood was removed on the left eye. You can see the reason for the angle of the knife in the preceding figures. The bottom must go up and in, and the top down and in.

We're in trouble if we don't get these eyes

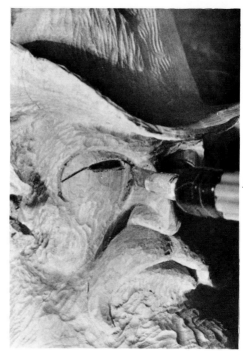

Figure 46

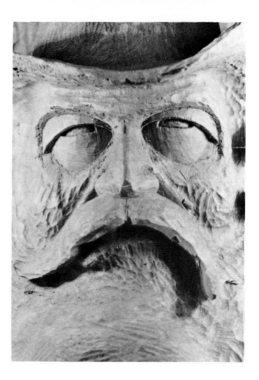

Figure 47

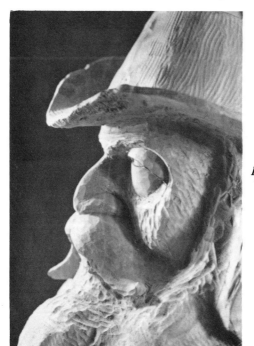

Figure 48

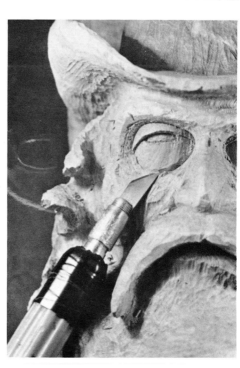
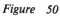

Figure 49

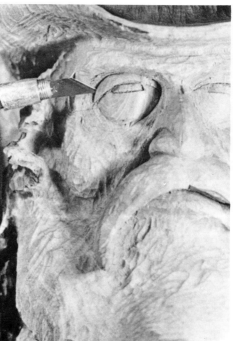

Figure 50

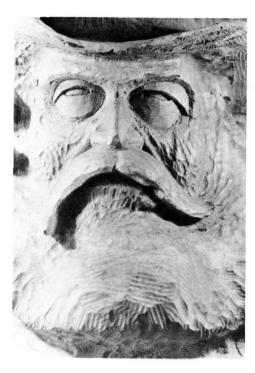

Figure 51

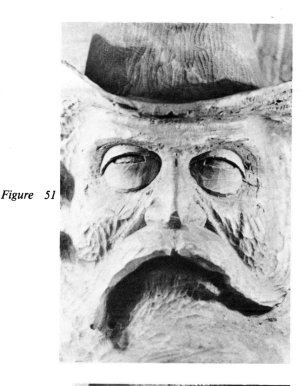

Figure 52

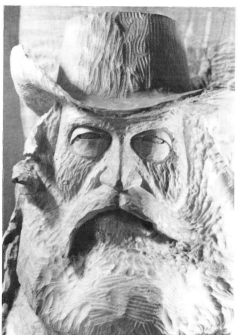

Figure 53

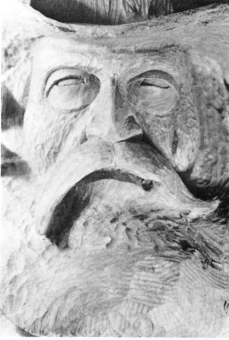

Figure 54

looking the same mighty sudden. Know what I mean? There, now he's in focus (Figure 52)! Do they have the same roundness? Are the eyeballs the same depth? View from the bottom end for uniformity of the eyelids.

He started getting the big head when work on the eyes began. You notice that? I never saw anyone so unstable in all my life. This better be the last time, fella (Figure 53)!

Wow, what a feeling! This wood carving gets hold of you, doesn't it? Especially the people sculptures. You will probably, as time goes on, try your hand at most everything that's carvable, as I have. You may also get *hung up* on the kind you can talk to and can identify with, the kind that will go on being a part of someone's family even after you are gone. Keep at it! You will be surprised at how much easier it becomes with the doing. Use this book to become acquainted with the basics, but try to develop your own distinctive style. It will bring more pride and gladness to your heart!

His lip is hanging out just a little **too** much in my opinion. Trim it all back, maintaining the same shape. Remove more wood from beneath it as well. No telling what blasphemies will proceed from this mouth once it is done, but we have to give him one! Most of it will be directed toward others of his own race I suppose, for there was nothing evil to say about his friends, the forest creatures. They weren't the ones that dynamited the beaver dams and clubbed to death every member of the colony, leaving none for propogation. Humanity needed lumber — that was obvious — but to take every tree from a stand of timber and leave the hillside to the ravages of erosion was a mite on the stupid side. We'd best not get this wise old mountain man

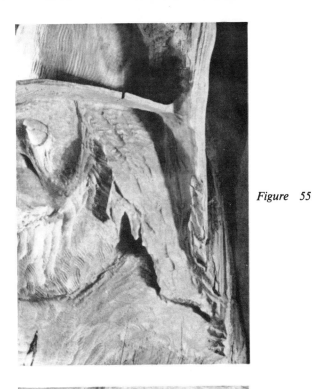

Figure 55

Figure 56

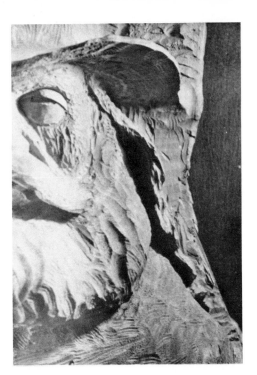

started on such matters, though, unless you can spare a few hours.

We want that lip to hang out to show his anger and contempt. This looks good for the final cut (Figure 54). Let's see what we can do with the beard and hair on the right side. Cut out his lower beard line to match the left side. Don't be concerned about a shoulder line, for it is hidden somewhere beneath that mop. Cut the hair inward to the side of the head. Give his beard the same fullness all around (Figures 55 and 56).

Remove the wood where his buckskin shirt opens (Figure 57). Cut inward to where you feel the chest would be in relation to the chin. Take away the wood from the entire shirt front, leaving the bearclaws as a unit. We will carve between them in a moment. We want the shirt to flare open slightly (Figure 58). Now carve between the claws (Figure

Figure 57

Figure 58

Figure 59

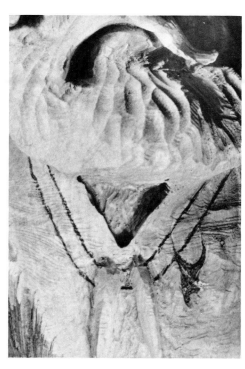

Figure 60

Figure 61

Figure 62

59). These are claws from the black bear, having more curvature than those of the grizzly. The black can climb trees, the grizzly cannot because his claws, being long and nearly straight, were meant mostly for digging.

The shirt front must go back farther yet to accommodate the martin tail on which the claws hang (Figure 60). Cut straight in on the lines using a small round bit. We want this martin tail to be round when finished, so cut deep enough to accomplish this. Using a small tool, trim around the claws to the level of the martin tail, then with a heavy tool bring the rest of the shirt front to the same level (Figures 61 and 62).

Looks like we need to remove more wood from the neck at the shirt opening, too (Figure 63). Give the claws a little more curvature, then carve out the undersides (Figure 64).

Figure 63

Figure 64

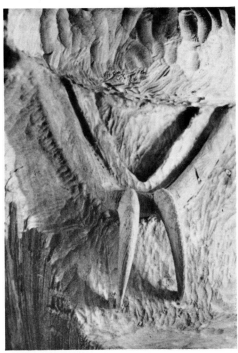

Figure 65

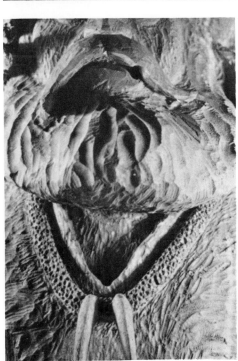

Figure 67

The claws of the black bear are beveled inward on the top, forming a sharp ridge from end to end, as you can see in Figure 65. The grizzly's claws are more rounded and comparatively straight. The ground dwelling animals were high on the grizz's menu; squirrels, marmots and such, but had to be dug out. A friend of mine, while hunting deer, happened upon a giant grizzly that was digging for marmots. He felt an overwhelming urge to head for the next state, but being no more than fifty feet from the rarest spectacle imaginable, he could not have been paid to leave. The bear was reaching into the marmot hole the entire length of his front leg, his huge head thrown back and his eyes rolling. The marmot then did the only thing left for him — he took a chunk out of that bear's paw! Ol' grizz let out a roar that shook the mountain, jerked his paw from the hole and with terrible anger began slashing at the small, surrounding trees with his enormous paws. In an ever widening circle he smashed them down and shredded them with his teeth, while the vicious roaring and snarling stormed on and on.

My friend stood mesmerized; overwhelmed by the awesome brute power of the beast. With one last swipe at a four inch birch, the bear loped off around the mountain and my friend sat down! He had just witnessed a phenomenon probably never before seen by man.

With the tiniest round bit you have, cut beneath the martin tail all around. Not deep — just enough to make the shirt disappear beneath it when viewed from the front (Figure 66). With that same tiny tool give the martin tail some texture (Figure 67). Don't be timid — rough it up good — it must **look** like fur! The beard didn't escape the wind so a windblown look is needed. Any configuration is

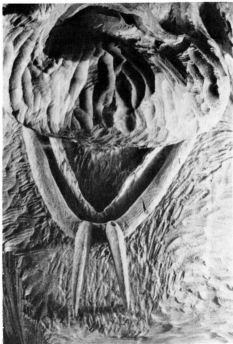

Figure 66

OK, so long as it flows from left to right, something like Figure 68.

Now that the head is in place let's finish the hat. Not only must the sides fit the head, but you must be sure the front does, too. It was just last week that the wind blew this old boy's hat in the lake and he had to shuck his clothes and swim like crazy, for the hat was making blame near as good a time as he was. By the time he caught that lid and made it back to shore it was mighty soaked, including the leather hat band. Of course the cussed thing shrunk up so tight he couldn't get the hat on, so he just took the band off and shucked it. Don't need it anyhow!

The best way to measure that turned-up brim is with a flexible measuring tape. Measure it on the bottom side. Trim it down to the same width as the right side. The front shouldn't be quite as wide,

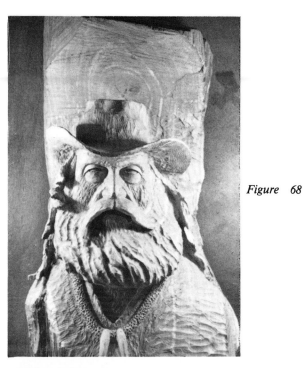

Figure 68

though. Remember the cowboy's hat? The brim on my guy's hat is two inches on the sides and one and one half in front (Figure 69).

Yes, I know his beak is too long! I was getting to it. But if we trim his nose, the mustache will have to be worked on, too — is there no **end** to this? There, is that better (Figure 70)?

Give him a dab more character with a few wrinkles and creases as shown in Figure 71. Now, turn him over and trim the head and hair up to the hat.

You may want to stick with the rasp for finishing, but I want to show you another way that I like. It gives a more weathered, rustic look. I will use the same tool on his face that is used on his hair — the dull 1/4 inch round bit. Everything else gets the same treatment as well — his hat and shirt.

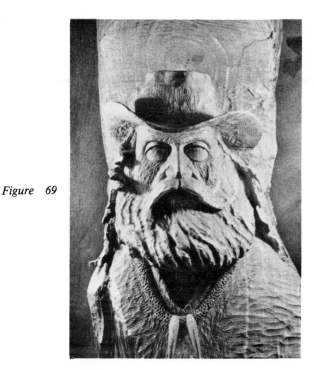

Figure 69

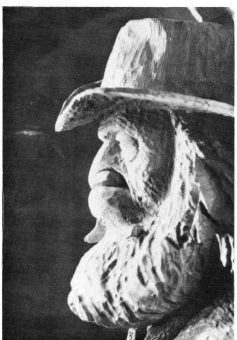

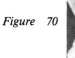

Figure 70

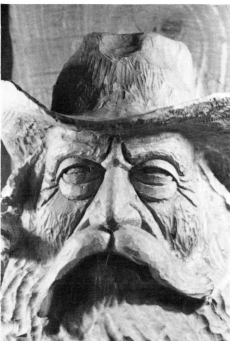

Figure 71

Figure 72

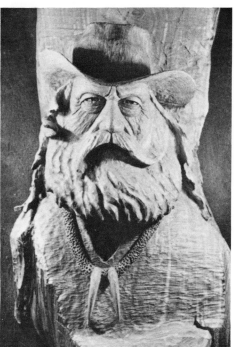

Go crossways on the shirt and anyway you can on the hat. A small bit must be used in the tight spots and the wrinkles need the touch of the rasp. Here's the way it looks (Figure 72). I recessed the eyeballs a bit more before drilling the holes, too.

I will have to be specific for the next job. We will be using the 1/8 inch drive pointed burr. The little bugger is tiresome to use, but I like what it does. Use it on all the hair. Cross over from one cut to another much of the time — it gives the hair more movement (Figures 73 and 74). Give him a couple of nostrils with that bit, too. It also does a better job if it is dull because it gets so hot it burns the wood, giving a darker tone on the hair.

Well sir, with that *smoke stack* in his mouth, the uncarved ends finished, and my John Henry signed on it, I sit here mighty proud. You too, huh? That's great! Good feeling, I'm sure you agree. What was once a mere, humble hunk of wood is now a vibrant, life loving man of the mountains and proud to be (Figure 75)!

His name is Beaver Man, given him by his Indian brothers who share the trails with him. He lives in the mountains and he will die there, being mourned only by those who know him best — God's wild creatures of the mountains.

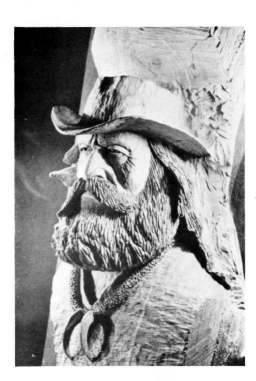

Figure 73

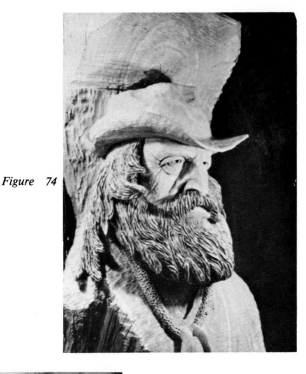

Figure 74

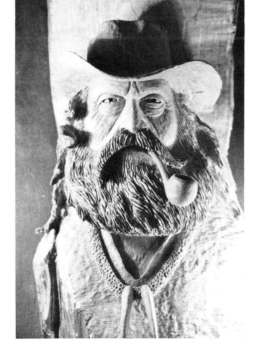

Figure 75

CHAPTER 4
BITS & PIECES

WOOD
TOOLS
REPAIRING CRACKS
FEATHERS
PIPES

CHAPTER 4
BITS & PIECES

WOOD

Most any wood will do to start with as long as it is **dry,** Go to the woodpile, cut a dead limb from a tree, drag home a piece of driftwood — anything. You will probably burn the first one anyway!

I am not an authority on the varied species of wood so will not attempt to advise on the relative merits of any one type.

In my opinion, Douglas Fir is the most **undesirable** carving wood because the growth rings are so much harder than the *in-between* wood. Any other wood with like texture should not be used because any finishing pressure that is applied — rasp, sandpaper, etc. — tends to remove the wood from the soft areas and leave the harder growth rings, resulting in a rippled effect.

Spruce is low on the list as well; it's like a new pair of Levis — **it shrinks!**

High on the list of carvability are walnut, cherry, pine, basswood, redwood, butternut, avocado, cedar and many imported varieties.

Availability is the number one factor in wood selection. If carving is only a hobby for you the purchase of special woods is probably not prohibitive.

My favorite is juniper, not only because the supply is ample but also for its character and color. It is a scrub desert tree that grows every way but straight, is relatively soft and very close grained. Smells good, too!

Good grain and color should be high on one's list as well as a density that will allow you to get a knife into it with little effort. Of course the wood does not have to be round to produce a face. A four by four from the lumber yard will do as well.

I have chosen a wood with good color because all my faces are left in the natural state. Color can be added very effectively to wood that has little or none.

The size of your faces is of little importance. A tiny two inch face can be just as impressive as one three times that size. Most of mine are in pieces from twenty to thirty inches long with a width of six or seven inches. Some, however, are smaller.

Nearly anything can be carved from a piece of wood, but faces are the greatest challenge and the most fun. After all, has anyone ever carved a personality into a duck? Try putting a grin on the face of a horse!

So regardless of the wood you use, there is someone inside and they will love you for setting them free!

TOOLS

Figure 1

The most important tool, though perhaps better called an asset, for the production of art of any kind, is **light**. Lots of it!

I find overhead, fixed position lights inadequate because they cannot put the light where it is needed in every situation.

May I suggest the use of adjustable arm lights — one on each side of your work and close enough to be positioned for illumination of any part of your piece.

There is no shortage of carving tools on the market; every kind of knife imaginable, gouges for a thousand needs, rasps of every conceivable size and shape, chisels and mallets and on we could go. There is a use and a user for every one of them, else they wouldn't be there.

But everyone who makes things — whether carver, painter, carpenter or knitter — has a favorite method and a favorite set of tools. Two people can begin identical projects with totally different tools and achieve the same results.

The only possible way I can show you how **I** make what I **do** is to do so with **my** favorite tools. If I suggest using a certain tool but you feel more comfortable with another — use it — as long as the job gets done!

I find the Sears hand grinder, or die grinder, as some call it, adequate for my needs (Figure 1). In fact I have four, but there is usually one in the hospital at any given time. There are many makes and models, but I would not recommend one brand above another. Although I feel air powered tools are much better than electric, if one can afford the first cost.

I am hopelessly addicted to the short, heavy handled Xacto® knife (Figure 2) which uses the heavier blades. I also like the lighter knife that uses the No. 11 blade, but the handle is so slender that it cannot be held tightly. To remedy this, bore a hole — the size of the handle — in a small block of wood and trim the block to any shape you like. Insert just a little glue and force the handle into the hole. Figure 2 also shows the Xacto blades I like. No. 24 — the larger — and No. 11.

The rasps (Figure 3) are but two of dozens of models. How ever many you choose, at least one should have a three-sided, sharp tipped end. It is almost a sin to carve without it!

Figure 4a is a ⅜ inch straight shank router bit with ¼ inch drive. It gets all the preliminary work, the tough stuff. Without it you can add hours to a job.

Figure 2

You will love the tool in Figure 4b — a ⅝ inch rotary rasp. It is real smooth but the wood really flies. It is cheap and doesn't last but will do you a job.

Figure 4c gets a lot of use — the ¼ inch round bit. It cuts very lightly and puts in a lot of time in finish work.

The foregoing were ¼ inch drive bits. The following are ⅛ inch drive and are made by Dremel® . If you plan to use a Dremel power tool, they are the right size, but for most other power tools you will need a collet (reducer, shown in Figure 4d) to reduce from ¼ inch drive to ⅛ inch. These can be obtained from your Sears store.

Figure 4e — ⁵⁄₁₆ inch round bit (Dremel No. 114)
Figure 4f — ³⁄₁₆ inch round bit (Dremel No. 192)
Figure 4g — ⅛ inch round bit (Dremel No. 191)
Figure 4h — ³⁄₃₂ inch round bit (Dremel No. 190)
Figure 4i — pointed burr (Dremel No. 118)
Figure 4j — ⅜ inch circular saw (Dremel No. 199)
Figure 4k — ¼ inch circular saw (Dremel No. 198)

Figure 3

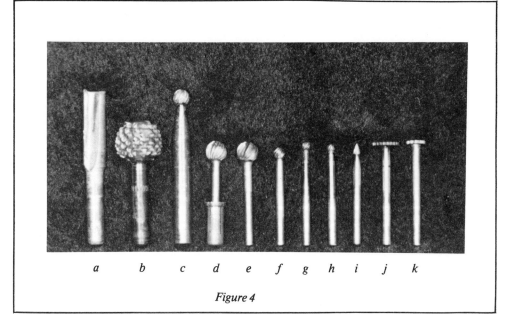

a b c d e f g h i j k

Figure 4

No words will be wasted here discussing how to **keep** wood from cracking. Weathering will cause cracking because that is the way some of the moisture escapes. There is pressure and tension within a tree due to holding itself in shape as it grows. When some of the wood is removed, as it is in carving, a *brace* is destroyed and the wood gives way, resulting in a crack.

I feel the best policy is to let it crack! If it gets rid of its tension — gets it out of its system, you can repair it and it won't open up later.

If you must repair a crack in the **end** of a piece (Figure 1) form a small wedge, being sure the grain is going the same way and after a little glue has been applied, tap it into the crack (Figure 2). Cut it across on both sides and it will break off easily. Continue with as many as needed — forcing them tightly together. It will finish off nicely (Figure 3).

REPAIRING CRACKS

Figure 1

Figure 2

Figure 3

Figure 4

Figure 5

Figure 6

Figure 7

Figure 8

Figure 9

A crack in the side of the wood (Figure 4) must be repaired in the same way only forming a wedge with the **side** sharpened so the grain will again be the same. Glue and tap in (Figure 5). It forms a bond that is nearly invisible (Figure 6).

Sometimes a larger crack must be repaired even before a piece can be used (Figure 7). Straighten the sides of the crack as best you can so as to accommodate a wedge as shown in Figure 8 (the sides of this crack were straight but for some reason they do not appear to be).

Using wood from the same piece, form a wedge to fit as closely as possible (Figure 9). Smooth the irregularities from the sides of the wedge with your small rasp. We want the edges rough. Place it in the crack and hit it sharply with a hammer several times. Any high spots on the sides of the crack will

Figure 10

have more contact on the sides of the wedge due to the blows. These spots will appear shiny as opposed to the rest of the area which will remain dull and rough. Trim the shiny areas from the wedge, apply the rasp and repeat. After a few treatments you will have a snug fit. Apply glue and clamp. You must look closely to see the repair (Figure 10).

FEATHERS

There are as many variations in feathers as there are species of birds, but the overwhelming favorite among the Plains Indians was the plumage of the mighty eagle. Obtaining the feathers was a feat demanding extraordinary patience and bravery — quite a story in itself.

The wing feathers saw the most use, but not to the exclusion of the tail feathers. How the Indians wore the feathers conveyed many messages — whether straight up, sideways, the top clipped at an angle, a certain number of notches cut out or painted in various ways.

Figure 1

Others could see how many coups had been counted by observing a warrior's feathers. Whether he had killed an enemy could also be known. Feathers were not merely ornamental, for they told these and other stories without the spoken word.

My feather making method is no better than another person's, and since feathers vary so much I have never considered their making, in an exact likeness, necessary. They are but supporting actors and must perform well, though not snatching the glory from the lead role.

Always use a blank that is considerably longer than the feather you intend to make. It's nice to have lots of wood to play with. The piece I am using, Figure 1, is 7½ inches long, 2 inches wide, and ⅝ inch thick.

Figure 2

Sketch your choice of feather, whether long and pointed, wide and blunt or any other variation (Figure 2). If you mount it so that it appears to be fastened at the back of the head, only a little more than half will be showing, so you must adjust for that.

Figure 3

Figure 5

Cut out the feather, and with the ⅝ inch rotary rasp, hollow out the center and taper the other side to fit the curve (Figures 3 and 4).

Draw the center rib something like this (Figure 5). Cut straight in on the lines and trim the sides in to the cuts (Figure 6).

I like the ⁵⁄₁₆ inch round bit for the next step, but nearly anything will do, even the knife. We want to give it a ripple effect from end to end (Figure 7). I never finish the back side for a wall hanging piece because no one ever sees it. Carve the edges of the back to fit the ripples on the front.

Cut three or four notches in the sides, then with the tip of the knife make as many light cuts on the face as you have room for. When you get to the notches with those little cuts, turn them to follow the edges of the notches. Now, make light cuts as close as you can on the sides of the feather. When did I learn Greek? Only recently. The pictures can probably say it better (Figures 8 and 9). The finish will soften the tone of it somewhat.

Figure 4

Figure 6

Figure 7

Figure 8

Figure 9

PIPES

There are probably no more than a zillion varieties of pipes and some are so intricate that, if stuck in this old trapper's mouth, they would grab all the attention.

I will attempt only to show you the basics that work well for me and you can make the pipe as fancy as you like.

The pipe must be the right size to fit the figure you are carving. That's simple enough but must be considered.

Select a piece of wood that is thick enough to make the bowl as **wide** as the **depth**, front to back. Sketch the pipe with the end of the stem extending **with** the grain (Figure 1). Remove the wood that isn't the pipe with what ever tool is easiest for you — bandsaw, jigsaw, coping saw, etc. I just block it out with the table saw (Figure 2). Then

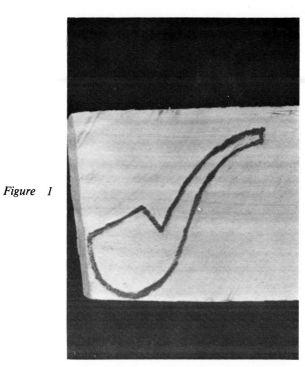

Figure 1

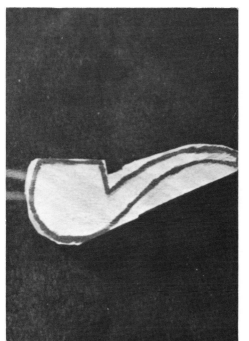

Figure 2

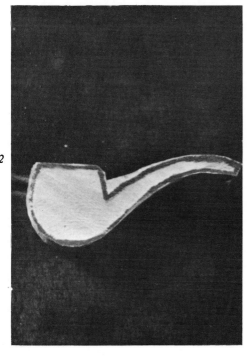

Figure 3

Figure 4

Figure 5

shape it to the lines as best you can with the rotary rasp (Figure 3). Continue the general shaping with the same tool (Figure 4). Then use the knife for the final shaping and finish with the rasp (Figure 5). The 3/16 round bit works well for hollowing the bowl (Figure 6).

If your piece is wearing a beard the bowl of the pipe can be glued to it after a small indentation is made in the beard so the bowl will fit snugly. That small, wooden stem cannot be depended upon for stability.

Here is a trick to strengthen the stem if there is no beard to fasten the pipe to. Select a small nail, cut the head off and bend it to fit the curvature of the stem. It must be long enough to extend from the tip well back into the *meat* of the bowl (Figure 7). With a round bit only slightly larger than the nail

cut a groove the full length of the under side of the stem (Figure 8). Adjust the bend of the nail to lie loosely in the groove. It must not be forced because you will only succeed in breaking the stem. Apply glue the length of the groove and push the nail in very gently. Let it dry and you have an invisible *steel-belted* pipe.

Figure 6

Figure 7

Figure 8

FRIENDS I WOOD
LIKE YOU TO MEET

There have been enough of these wooden folks come out of my shop to populate a small town.

Here are a few of my best friends — after the sawdust has been removed from around them. They have all found happiness just hanging around other people's homes, and I am happy to have been able to contribute.

Feel free to use them as models, and I hope **your** creations will soon have the honor of being a part of many people's lives.

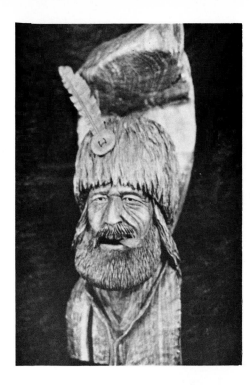

Gold Pan Dan

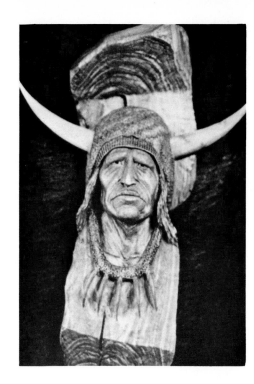

Sioux Chief

Crow Brave

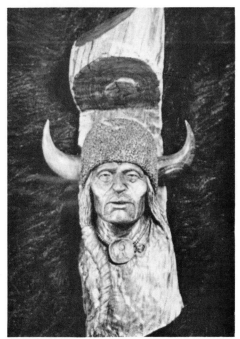

One of the Boys

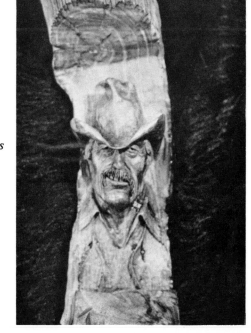

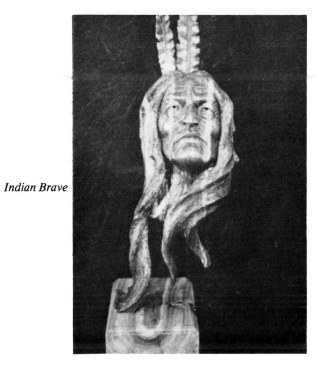

Indian Brave

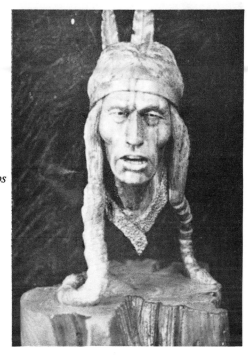

Many Coups

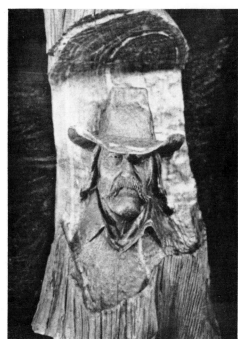

Wagon Master

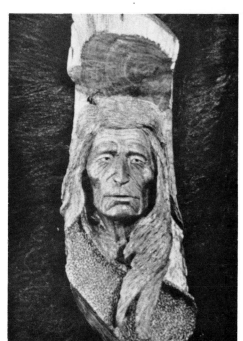

The Wise One

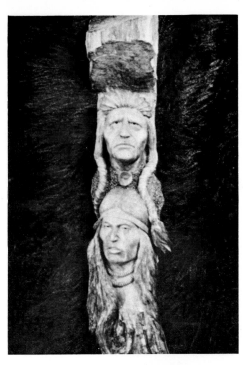

Blood Brothers

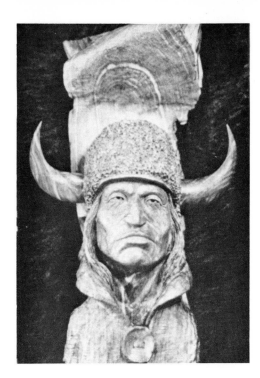

Comanche Warrior

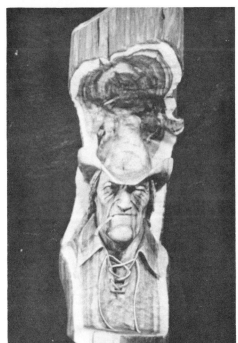

Ramrod

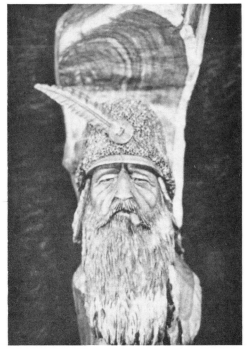

Beaver Man

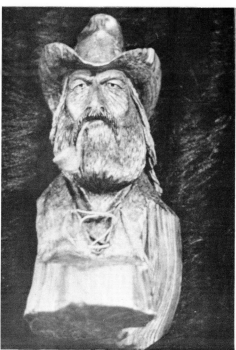

In From the Hills

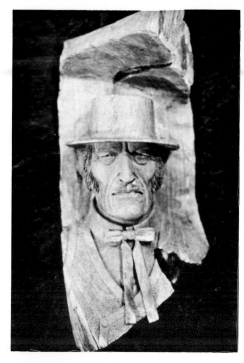

Ol' Slick

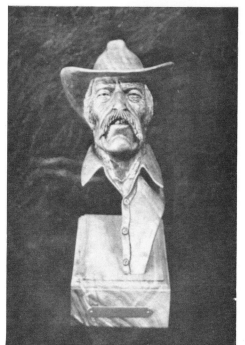

Sea Dog

Don't Push Me

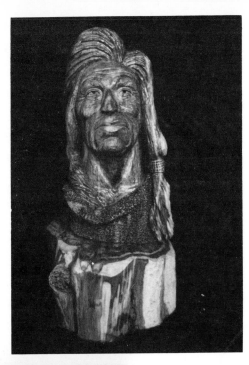

Many Coups

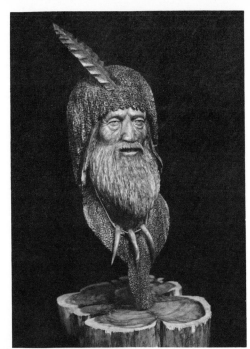

Beaver Man

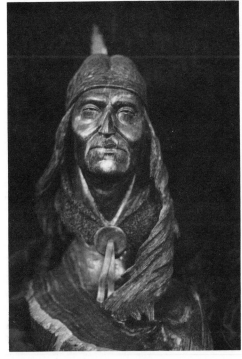

Indian Scout

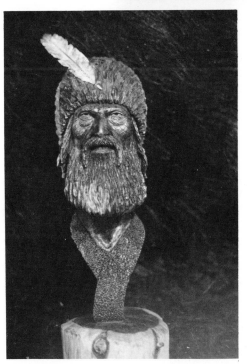

Mountain Man